DRAWINGS
FROM THE
KRÖLLER-MÜLLER
NATIONAL
MUSEUM,
OTTERLO

travis

van Gogh:
Man with a Pipe. 1882.
Lithographic crayon and pencil,
heightened with gouache,
17¾ x 10⅞ inches

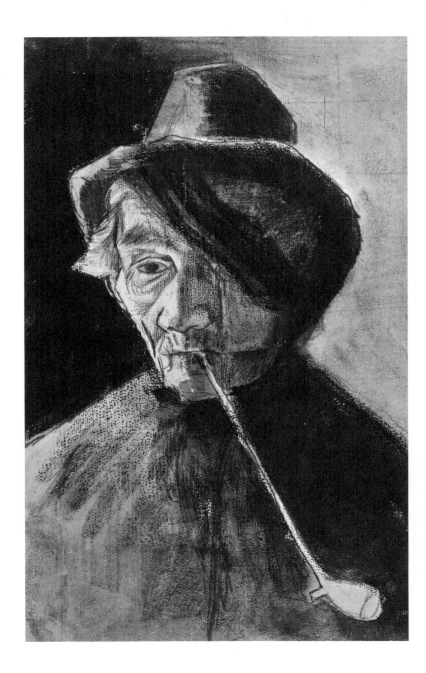

DRAWINGS FROM THE KRÖLLER-MÜLLER NATIONAL MUSEUM, OTTERLO

Edited by

William S. Lieberman

The Museum
of Modern Art,
New York

Library of Congress Catalog
Card Number: 72-95074
ISBN: 0-87070-297-1

Designed by James Wageman
Printed in the United States
of America

COVER
van Gogh: *Cypresses with
Two Women*. 1889. Reed pen
and ink, chalk, and touches of
oil, 12⅝ x 9½ inches

SCHEDULE
OF THE
EXHIBITION

This catalogue is published in conjunction with an exhibition sponsored by the Netherlands Ministry of Cultural Affairs, Recreation, and Social Welfare and shown in the United States and Canada under the auspices of The International Council of The Museum of Modern Art.

The Museum of Modern Art, New York	May 24–August 19, 1973
The Art Institute of Chicago	September 8–October 21, 1973
The National Gallery of Canada, Ottawa	November 9, 1973–January 1, 1974
Marion Koogler McNay Art Institute, San Antonio	January 13–March 3, 1974

CONTENTS

ACKNOWLEDGMENTS On behalf of the Trustees of The Museum of Modern Art, I wish to thank the Netherlands Ministry of Cultural Affairs, Recreation, and Social Welfare and also The International Council of The Museum of Modern Art, under whose auspices the exhibition is being shown.

In Otterlo, Rudolf W. D. Oxenaar, Director of the Kröller-Müller National Museum, allowed me rewarding hours of study as well as other courtesies. Miss Ellen Joosten, Assistant Director, has been helpful at all stages of the exhibition as guide, mentor, and friend. Their collaboration was particularly generous because during 1972 they were occupied with the selection and installation of two very different exhibitions: *From van Gogh to Picasso,* nineteenth- and twentieth-century paintings and drawings from the Pushkin Museum in Moscow and the Hermitage in Leningrad; and *Diagrams and Drawings,* a survey of studies on paper for environments and for minimal sculpture by thirteen American artists.

In New York, I wish to thank my colleagues at The Museum of Modern Art, in particular: Mrs. Harriet Bee, Mrs. Antoinette King, Richard Palmer, Waldo Rasmussen, Mrs. Monawee Richards, Mrs. Bernice Rose, and Hans van den Houten. The exhibition itself has been made possible through the generous sponsorship of Heineken Breweries, Van Munching & Co., Inc., The Algemene Bank Nederland N.V., and the assistance of KLM Royal Dutch Airlines as well as The New York State Council on the Arts.

At the Art Institute of Chicago, Mr. Leigh B. Block, Mr. Harold Joachim, and Mr. John Maxon have encouraged the project from its inception as has Dr. Jean Sutherland Boggs, Director of the National Gallery of Canada, Ottawa, and John Palmer Leeper, Director of the Marion Koogler McNay Art Institute, San Antonio, Texas. Lastly, I would like to acknowledge the special contributions of Mme Juan Gris, Paris, Mrs. Walter N. Thayer, New York, and P. F. Hefting, curator at the museum in Otterlo.

W.S.L.

"The collection of drawings comprises more than four thousand pieces by Dutch, Italian, French, German, Spanish, Japanese, and Belgian masters, both modern and old. The largest number is of Dutch origin. They have all been mounted, numbered, and arranged in boxes, and they can be shown on demand." Written in 1933 by Mrs. Hélène Kröller-Müller, in an explanatory note to the Dutch government about her collection, this description is one of the most concise passages accorded a specific category among her extensive and comprehensive possessions of works of art.

Mrs. Kröller's first and lasting attachment was to painting, but this does not mean that other facets of her collection—sculpture, drawings, prints, and decorative arts—were brought together with less care and devotion. It was typical of her that she never looked only for acknowledged masterpieces and that she always had an eye open for new developments and unknown territories. The small and seemingly unimportant received her attention as much as did the unexpected greatness of lesser-known artists. Her collection never became a simple enumeration of high points but presented a stream, a continuity, that increased in value through its intrinsic coherence.

In 1933, indeed even by the late twenties, her collection was essentially complete. Until her death in 1939, only some relatively minor additions were to follow. The nucleus had been formed between 1907 and 1920, with the prewar years comprising the most important period. From 1913 onward, and especially after 1920, architectural plans became the central preoccupation of her cultural activities.

It is well-known that the unique series of paintings and drawings by Vincent van Gogh, now totaling 272 works, formed the heart of her collection. Around it she arranged a survey of modern art as she saw it in reference to her own time and opinions. She aimed at objectivity but, with the help of her lifelong adviser, the art critic and pedagogue H. P. Bremmer, she found a happy balance between art-historical considerations and personal preferences. The collection became an entirety of such clarity and stature as is rarely achieved by private collectors.

The introductory quotation is indicative of Mrs. Kröller's manner of keeping art and making it accessible. She was, indeed, a meticulous and orderly woman. Also, she did not want to surround herself with rare and beautiful objects for purely personal reasons but saw it as a privilege to be able to do this, a privilege she wished to share with others. In her choices,

Mrs. Kröller always showed a strong educational motivation consciously directed toward the community. Also, she repeatedly expressed, and put into practice, her conviction that there are no real demarcation lines in art, that old and new, European and non-European can not only be shown together, but belong together. The very personal character of the collection is marked by her preference for the harmonious, the classical, and the spiritual in art.

Her definition of art as "the emotional objectivation of the spiritual ego, with no other purpose than to objectivate this ego" became a reality in a personal choice accented by objectivation. Her choice was Apollonian, often with the intentional exclusion of the Dionysiac, as is most clearly shown in her deliberate denial of all forms of expressionism after van Gogh. Mrs. Kröller saw art at that time, and in her terms, as a development from realism to idealism—the idea leading to a new reality. From such aesthetic convictions, which she mainly owed to Bremmer, sprouted the open-mindedness that enabled her to follow and understand the essence of what happened in the revolutionary years from the late nineteenth century to Mondrian's last stages of personal cubism just before 1920.

Drawings played a comparatively minor role in her collection. Yet the qualifications traced above are also present within this category, albeit in somewhat vaguer terms. Although painting always came first, no specific field was, at any period, really neglected. The limited information left us by Mrs. Kröller shows that most of the drawings were bought in the twenties when the impetus to buy major works of art had lessened under the strain of the economic crisis. The size of the drawing collection, some four thousand sheets, does not represent an impressive total in terms of a museum drawing cabinet, but this was never intended for it. Included in this number are about 850 drawings ranging in time from the fifteenth through the eighteenth century. This exhibition was chosen only from the nineteenth- and twentieth-century drawings in order to stress the main principles of the entire collection.

Although many important details are missing, it is still possible to give a reasonably complete general outline of Mrs. Kröller's acquisition policies in the field of drawings. Practically all purchases, and this is true not only for drawings, were effected by Mr. Bremmer on the basis of his proposals and after consultation with Mrs. Kröller. This would make it easy to think of Bremmer as a man who traveled about Europe visiting art centers, getting

information, preparing new possibilities, and constantly reporting back to his principal. The real situation was different, however; both Mr. Bremmer and Mrs. Kröller traveled only occasionally, even during the days of their almost feverish collecting activities. Nevertheless, much seems to have been achieved on a few well-prepared trips.

We have, for example, Mrs. Kröller's personal report to her husband of an incredibly fruitful visit to Paris with Bremmer in April, 1912. In two days, they acquired seven major paintings by van Gogh (among them, *La Berceuse*, the so-called *Portrait of an Actor*, *Still Life with Apples in a Basket*, the green *Olive Grove*, and the *Ravine, Les Peyroulets)*, two early van Gogh drawings, the *Harbour Entrance at Honfleur* by Seurat, and the famous *Breakfast* by Signac.

The provenance of the drawings reflects the fact that there was relatively little traveling done by the collector. The majority were bought in the Netherlands. Acquisitions abroad were comparatively rare, although good contacts were maintained with dealers such as Paul Cassirer in Berlin and Léonce Rosenberg in Paris, who furnished most of the cubist drawings. Also, fairly regular purchases were made at sales, especially in France and Germany. In general, most purchases were made through art dealers and at sales, and sometimes also from private collectors, but seldom directly from artists. It could be that this also reflects the social structure of the period and the social position of the persons involved.

Both Mrs. Kröller and her adviser, Mr. Bremmer, were reticent and aloof personalities. As the wife of one of the most influential Dutch businessmen of the time, Mrs. Kröller lived a fairly secluded life, fully devoted to her cultural activities, which she saw as her lifework. She was in no way a society celebrity. Bremmer, himself a painter of some merit and a friend of many of the Dutch artists of his generation, nevertheless always kept his distance. His lecture courses, mainly for small, private groups of well-to-do people, and his extensive correspondence, showing how over the years he always remained "Mr." Bremmer (no artist ever called him by his first name), are typical indications of his personal demeanor and reserve.

However, within a limited circle of almost exclusively Dutch artists, more direct relations did develop. Mrs. Kröller and Mr. Bremmer, in these cases, regularly acquired works of art by Dutch artists, motivated as much by sincere admiration as by personal friendship and social compassion. It is

against this background that one may, at least partially, view the extensive representation in the collection of Dutch artists like van der Leck, Dirk Nijland, Raedecker, Teixeira de Mattos, Thorn Prikker, Toorop, Verster, and Isaäc Israëls. The choice of drawings for this exhibition gives a fairly balanced idea of what Mrs. Kröller brought together. There is a small group of high-quality French impressionist paintings in the collection, but there are practically no drawings of that period. However, Mrs. Kröller did acquire some delightful watercolors by Jongkind. On the other hand, the so-called Amsterdam impressionists like Breitner, Verster, and Isaäc Israëls are copiously represented.

The center of interest is, of course, formed by some 150 van Gogh drawings, giving a rich and varied image of the production of his Dutch period but, unfortunately, including only five examples of the French years. In 1907, the acquisition of three paintings by van Gogh—*Sunflowers, Still Life with Lemons,* and *The Sower (after Millet)*—caused a breakthrough in Mrs. Kröller's ideas about art that transformed her from an interested amateur into a dedicated professional collector prompted by clearly defined principles. From the beginning she also bought van Gogh drawings. The earliest purchase was "a woman with a kettle," bought in 1908 from the Amsterdam art dealer C. M. van Gogh. In the years before World War I, she added about twenty others, but her holdings of van Gogh drawings became really important only during the last stages of her collecting activities when, in 1928, she bought 113 drawings from the Hidde Nijland collection.

Art Nouveau and, in a wider context, the art of the decades around 1900 were given ample and detailed representation. Here, both Mrs. Kröller and Mr. Bremmer found the roots of their relation to the arts. Bremmer made friends with Toorop and Thorn Prikker during his formative years in Leiden, where his father ran a hotel, and through them he came in contact with "Les Vingt" in Brussels. Theo van Rijsselberghe was, for many years, a special friend. In this artistic climate, Bremmer discovered the neo-impressionistic style for his own work, to which he remained true throughout his long life (he died in 1956 at the age of eighty-five).

As early as 1910, Mrs. Kröller became interested in Henry van de Velde's architectural work. She was fascinated by the house he designed for the family of a collector named Leuring in The Hague, near her own house. This led, in the twenties, to a series of architectural plans for the Kröller firm and

family, culminating in the grandiose design for a huge museum to be built in the middle of the family's private hunting grounds, the 15,000-acre Park de Hoge Veluwe. Construction started in 1921 but had to be stopped within a year because of the economic situation. The present museum building, van de Velde's last major work, was opened in 1938 as a temporary abode for the collection, awaiting completion of a larger museum, which, unfortunately, never followed. Van de Velde also had an important influence on the formation of the collection in its later years. On his advice, Mrs. Kröller bought several of the major paintings by Seurat, the neo-impressionists, and Léger. Ironically, all the drawings by van de Velde himself were acquired after World War II and some even in recent years.

Mrs. Kröller was one of the first admirers, next to his personal friend André Bonger, of Odilon Redon's work, in the Netherlands. Her example, propagated by Bremmer, was influential in causing several other collectors in the country to obtain work by Redon.

Among the works of around 1900, a curious note is struck by the remarkable group of pastels by the little-known Belgian artist Degouve de Nuncques, showing again the significance for the Netherlands of Bremmer's early relations with "Les Vingt."

Neo-impressionism is well-represented in the early drawings of Toorop, Thorn Prikker, and van de Velde, but it is a pity, and really an amazing omission, that Mrs. Kröller never tried to obtain any drawings by Seurat. Most of the cubist drawings entered the collection in the twenties. And it is again characteristic of Mrs. Kröller's and Mr. Bremmer's policies that they not only looked for works by Picasso, Gris, and Léger, but also had eyes for such lesser-known figures as Blanchard, Herbin, and even Jean Pougny.

The painting collection gradually developed from van Gogh to Seurat, to the cubists, and finally, to Mondrian. The formulation of Mondrian's neoplasticism in 1920 marks the art-historical limits of the collection. The last step to absolute abstraction was not taken.

A similar limit of understanding was reached in the work of van der Leck, but his return to a nominal presentation of reality saved him a measure of comprehension, although we do know from correspondence that Bremmer had difficulties with van der Leck's work. But surely "realism to idealism," from let us say, Corot and Courbet to Mondrian and van der Leck, seems to cover enough ground for a lifetime rich in insight and initiative. For more

than thirty years, from 1912 until World War II, van der Leck obtained regular financial support from Mr. Bremmer and Mrs. Kröller. This explains the very extensive holdings of his work in the Kröller-Müller Museum of forty-two paintings and almost four hundred drawings.

When, after World War II, it became necessary, for the first time, to decide what the future of Mrs. Kröller's collection would be, it was rightly decided that it would be impossible and erroneous to try to enlarge and complete the collection of drawings to the size and importance of a regular drawing cabinet. In only one specific, and comparatively narrow, field does the museum continue to acquire drawings: the realization of the sculpture garden and the related strong growth of the sculpture collection led my predecessor, Professor A. M. Hammacher, to form a collection of sculptors' drawings, which serve to accompany, explain, and illustrate sculpture, but are also seen and chosen as an independent species with innate properties.

The selection of drawings for this exhibition was made by William S. Lieberman. We have greatly appreciated close cooperation with him and are very happy that the exhibition exchange that he suggested, now almost five years ago, has become a reality.

RUDOLF W. D. OXENAAR
Director, Kröller-Müller National Museum

INTRODUCTION The Kröller-Müller National Museum in Otterlo, one of the most beautiful museums in the world, is idyllically situated in one of the few forested landscapes of the Netherlands. It is known chiefly for its extensive holdings of paintings by Vincent van Gogh and for a handsome sculpture park of twenty-seven acres. The museum, however, has many other treasures of which perhaps the least known is a collection of nineteenth- and twentieth-century European drawings.

At the core of this collection are more than 150 drawings by van Gogh collected by Mrs. Kröller. They date, for the most part, from between 1881 and 1885, when van Gogh had returned to the Netherlands from Belgium and before he left for France. Since Mrs. Kröller's death, however, a few additions have expanded the range of the collection—some childhood sketches drawn in 1862 and three drawings from van Gogh's final years in France.

Van Gogh has been the subject of unrelenting research. In addition, the drama of his life can not only embellish but also obscure appreciation of his art. He himself remains his best biographer, and his letters, chiefly to his brother Theo, offer an inexhaustible source of information. Less frequently studied is his correspondence with Anton van Rappard, a fellow Dutch artist. The two were almost exact contemporaries and their friendship lasted five years, from 1881 through 1885, the same period to which the majority of the Kröller-Müller drawings belong. Van Gogh's letters to Rappard are especially revelatory because he writes as an equal to another artist. He discusses his tastes in art, his doubts and hesitations, and particularly his apprenticeship at drawing on paper and stone. Although van Gogh did not hesitate to express opinions about Rappard's work, and to give him advice, he himself was annoyed when his friend disliked his lithograph *The Potato Eaters*, which repeats the composition of his first successful painting.

Van Gogh's maturity as an artist spans scarcely a decade. The vigor, power, and realism of his drawings in the Netherlands are, to some extent, eclipsed by the lyric animism of those done later in France. The earlier drawings are often heavily reworked, and it should be remembered that until 1885 van Gogh remained essentially a draftsman. Often, on a single sheet, one can read the actual drama of creation whether it be a quick study of a peasant in the field or an interior worked and reworked into painterly chiaroscuro. Awkwardness, indeed, exists in certain passages. The total image, however, is always true and almost always eloquent. Several of the

drawings represent episodes in his own life, for instance his relationship with Sien, van Gogh's longest liaison with any woman. Drawings of Sien and her young sister are included in the exhibition. Van Gogh's own written words describe her in several of his letters to his brother Theo: "Last winter I met a pregnant woman, deserted by the man whose child she carried. A pregnant woman who had to walk the streets in winter, had to earn her bread, you understand how. I took this woman for a model, and have worked with her all winter. I could not pay her the full wages of a model, but that did not prevent my paying her rent, and, thank God, so far I have been able to protect her and her child from hunger and cold by sharing my own bread with her.... The thing with Sien is that I am really attached to her, and she to me; she has become a faithful helper who follows me everywhere, and becomes more indispensable every day. My feeling for her is less passionate than what I felt for Kee last year, but the only thing I am still capable of after the disappointment of that first love is the kind of love I have for Sien. She and I are two unhappy people who keep together; in this way unhappiness is changed to joy, and the unbearable becomes bearable.... Nobody cared for her or wanted her, she was alone and forsaken like a worthless rag, and I have taken her up and have given her all the love, all the tenderness, all the care that was in me; she has felt this and she is revived, or rather, she is reviving." Van Gogh's most poignant representation of Sien is as a nude. "My very best drawing," he wrote Theo, "at least I think it's the best I've done." The drawing was rendered as a lithograph and inscribed by van Gogh in English, "*Sorrow.*"

Van Gogh's later draftsmanship is less labored, and the sheets are less frequently reworked. At the beginning of 1886 he arrived in Paris. During the next two years the development of his style as a painter was rapid. He found new freedom in impressionist and neo-impressionist techniques. This is, of course, reflected in his drawings. In 1887 he also studied intensely a few Japanese color woodcuts, by various artists, which had been printed earlier in the century. These confirmed foreshortenings and close-ups which he had used, with instinctive authority, in the compositions of some of his earlier drawings in The Hague.

In 1888, van Gogh was thirty-five years old. He left Paris for the south of France. In the short remaining time, he was prolific as a painter. He produced, as well, the magnificent drawings in reed pen and ink for which he is best known as a draftsman. Further study of Japanese prints had led him to

illustrations by Hokusai. These prints were actually engravings of drawings which, in stark contrasts of black and white, combined stippled areas with animated flowing curves. Van Gogh was also impressed by their bold overall patterns and by their flattened perspectives.

More important is van Gogh's quick mastery of the reed pen as an instrument of drawing. He used it as a brush and as a scribe and alternated its rhythms and punctuations. Swirls, dots, and strokes burst with energy across the sheet of paper. The drawings themselves usually relate, sometimes posteriorly, to paintings. They also influenced his actual technique of painting, and in gouache, watercolor, and even in oil he sought similar effects.

The work of van Gogh is seldom seen in relationship to that of his other Dutch contemporaries. The collection at Otterlo offers such an opportunity, and a few drawings reproduced here suggest comparisons and contrasts to those by van Gogh himself. Apart from van Gogh, Johan Barthold Jongkind is the greatest Dutch painter of the nineteenth century. His watercolors and etchings reveal details surprisingly abstract and, on paper, his brushwork is extraordinarily free. There is little indication that van Gogh ever studied his work. Other Dutch contemporaries are more frequently mentioned in van Gogh's letters, for instance Jozef Israëls, the brothers Jacob and Matthijs Maris, and Anton Mauve, the latter van Gogh's cousin and, until his relationship with Sien, his mentor. August Allebé and Bernardus Johannes Blommers, like Israëls, depicted Dutch life and landscape. Their three drawings, reproduced here, might illustrate van Gogh's advice to Rappard. "Speaking only from an artistic point of view, I tell you that, in my opinion, you as a Dutchman will feel most at home in the Dutch intellectual climate, and will get more satisfaction from working after the character of this country (whether it be figure or landscape).... Then we are ourselves, then we feel at home, then we are in our element. The more we know of what is happening abroad, the better, but we must never forget that we have our roots in the Dutch soil."

Rappard himself earnestly sought to develop a personal style. He remained, however, a student, and his own brief life was bleak. One of his best drawings is a rendering of pollard birches, which may be compared with a similar subject by van Gogh. The Dutch impressionists, George Hendrik Breitner, Floris Verster, and Isaäc Israëls were younger than van Gogh. Their drawings and watercolors demonstrate a virtuosic spontaneity uncharacter-

istic of their paintings in oil. They deserve an audience beyond the confines of the Netherlands.

The achievement of van Gogh, of course, transcends nationalistic boundaries. Like Ensor, Munch, Gauguin, and Redon, he should be studied within the broad context of the symbolist movement. Today, a revived interest in symbolism explores the achievement of lesser artists who have, to a great extent, been either forgotten or ignored. In general, they belong more to the *fin de siècle;* their personal styles are mannered, and they are usually concerned with narrative. One curious artist is another Dutch contemporary of van Gogh's, Jan Toorop. He was born in Java in 1858 and died seventy years later in The Hague. He explored a variety of styles, but his most individual accomplishments are several large allegories, monochrome in color, drawn early in the 1890s. Two sheets, *Fatality* and *The Three Brides,* offer extraordinary hallucinations. They employ a whole battery of favorite symbolist images from sad maidens and polymorphous deities to lilies, thorns, candles, and reverberating bells. All elements of the intricately detailed iconography are woven together by waves of cloth and, not unexpectedly, human hair. Toorop's figures are often drawn in profile and their angular gestures and thin arms recall those of Indonesian shadow puppets. The sinuous patterns of Art Nouveau, however, are so insistent that their postures seem, instead, flaccid.

Many of Odilon Redon's most important drawings were collected in the Netherlands largely because of Jan Toorop, who first saw his work in Brussels in 1886, and André Bonger, a collector who become a friend of Redon's. Somewhat later, Mrs. Kröller also admired the visions of the French symbolist and collected some forty of his drawings in addition to several of his paintings.

Redon gave the title "les noirs" to the charcoals and lithographs that constitute his essential production as an artist until the mid-1890s. As usual, his own words are eloquent: "Around 1875 everything became clear. I discovered charcoal crayon, that powder which is volatile, impalpable, and fugitive.... This ordinary medium, which in itself has no beauty, aided my research into the chiaroscuro of the invisible."

Toorop was the original owner of an early charcoal by Redon, the *Head of a Martyr* (1877), reproduced here. The severed, hallowed head at once recalls a John the Baptist or an Orpheus, heroes much revered by symbolist painters and poets. Toorop was haunted by the image and, in 1893, wrote to

Redon: "I find your drawing superb and I am almost obsessed because of this drawing. It has a formidably suggestive expression and the expression of the martyr, the idea of suffering, masterfully [representing] a noble soul.... Now, if you do not find me too brutal, I am about to ask you if you would be so kind as to give me this drawing for the price of 100 florins.... My obsession for your drawing pushes me to offer you this price because I have nothing else to offer."

Redon's *The Marsh Flower*, a human head suspended above a swamp, and certainly the most memorable of his several flower heads, derives from a woodcut printed in color by Hokusai. Redon later reduced the image and rendered it as a lithograph for an album, which he conceived as an homage to that other great master of blackness, Goya. Less spectral, but more enigmatic, are two other drawings by Redon: *Woman and Serpent* perhaps represents some imagined Druidic rite rather than either a composition based on the letter "R" or, as has also been suggested, a phallic allegory occasioned by the birth of his son; *Woman in Profile,* one of the last of the long series of "les noirs," anticipates his series of painted flower pieces, many of which include single heads of women.

Politically as well as intellectually, Paul Signac was associated with the symbolist poets, painters, and critics in France. Pictorially, however, this relationship was brief unless the divisionist technique of painting of some of the neo-impressionists can be considered as a manifestation of symbolism itself. His small sketch, *A Time of Concord,* is a preliminary study for a large mural that now decorates the town hall of Montreuil. When shown at the Salon des Indépendants in Paris in 1895, the following legend accompanied the painting: "The Golden Age is not in the past, it lies in the future." The somewhat ponderous allegory presents, in the landscape of St. Tropez, what Signac believed to be a romance of utopian anarchy, a new society. In technique, the charcoal relates to the luminous drawings of his friend Georges Seurat as well as to two black-and-white lithographs by Signac himself.

The subjects of three Belgian artists, Rops, Khnopff, and Degouve de Nuncques also belong to the symbolist repertory. The demeanor of Félicien Rops's goddess suggests qualities less than divine and which, in his other works, become erotic and perverse. Fernand Khnopff was an anglophile, and at one moment Oscar Wilde considered him as an alternate illustrator to Beardsley. "I want something curious," wrote Wilde, "a design of Death and

Sin walking hand in hand, very severe, and medieval." Khnopff's ideal of female beauty was constant, the broad-jawed face of his sister who, in his work, appears as siren, sphinx, and angel. The drawing reproduced is a study for a larger pastel on permanent loan to The Museum of Modern Art in New York. William Degouve de Nuncques, a friend of Toorop's, is perhaps the least known of the Belgian symbolists. He is represented in the Kröller-Müller collection by several paintings and drawings. Three of his pastels are included in the exhibition: views of a park in Milan, a canal in Venice, and a swan gliding on the water. The swan, that most ambivalent of symbolist images, is black; in the water float lilies, and, on the river bank, the trunks of leafless trees are encased by vines. All three drawings are equally mood-drenched by a still and melancholic atmosphere of twilight, in dark blue and green.

The figure of the Belgian artist Henry van de Velde dominates the development of Art Nouveau in Europe. For many years he was close to Mrs. Kröller and worked on several of her projects. More than any other architect, it is he who is responsible for the design of the Kröller-Müller Museum as it appears today. After World War II, the museum acquired several of van de Velde's drawings. These date from early in his career, which he began as a painter. The drawing of a gourd closely approaches abstraction, and the composition and colors are completely decorative. Less well-known are other drawings such as *Girl in a Farmyard* where separate ribbons of color construct the design—a method of divisionism which differs from the pointillist technique of his own paintings of the same time. A similar, less undular, divisionist technique was evolved by Johan Thorn Prikker. His landscapes in pastel fall between his earlier symbolist and later abstract periods. Sometimes they seem without perspective, beautiful, almost abstract clusters of straight strokes of color. In his studies of haystacks, form is more realistically described and the strokes of pastel follow the actual shapes.

The Kröller-Müller Museum owns several significant canvases by the cubist painters of Paris. Among these, two masterworks by Fernand Léger, *Nudes in a Forest* (1909–10) and *The Card Players* (1917), are well-known today. They were purchased quite early, probably on the advice of Mrs. Kröller's architect, Henry van de Velde. Less familiar is a small group of cubist works on paper.

It is surprising that such a monumental sheet as Pablo Picasso's *Standing*

Nude, drawn late in 1908, is unrecorded in the catalogue raisonné of his oeuvre or any of its supplements. Although the head recalls the characteristic chignon worn during those months by Picasso's friend, Fernande Olivier, the gouache is in no way a likeness. The frontal pose contrasts with other studies, on paper and canvas, of the same nude also standing, or seated or crouching. The drawing is listed as the last lot to be auctioned in the catalogue of the first Léonce Rosenberg sale held in Amsterdam in February, 1921.

Five still lifes by Juan Gris record essentially the same objects. The first easily defines in space a glass, a bowl, and a pitcher. In the second and third drawings, also of 1916, contours are more broken, and light and shadow are contrasted to flatten the pictorial space and to reintegrate the objects themselves as a pattern. The two drawings of 1918 also make use of a tilted perspective that derives from Cézanne. These two later still lifes, however, are much more concerned with descriptive detail and demonstrate Gris's return to realism, which parallels, also on paper, that of Picasso.

The date of Auguste Herbin's self portrait is 1909, the year in which he installed himself in Montmartre in the same building where Picasso and Gris lived and worked. The drawing is a full-scale study for the painting in the Museum of Modern Art in Stockholm. It reveals an understanding of the planar analysis of cubism, which Herbin was rarely to repeat.

Léger worked on the theme of *Le Grand Déjeuner* for almost three years. The composition situates three nudes in an interior. The final and largest version is the painting owned by The Museum of Modern Art in New York. Three drawings in the Kröller-Müller collection should be studied in conjunction with the final painting of 1921 as well as with earlier and concurrent smaller, painted versions. The horizontal sheet, which gives the full composition, is close to a painted version, about two feet high, of 1919. It also helps identify some of the furnishings of the room which are not always as specifically articulated in the paintings. The two vertical sheets were drawn a few months later and supply, respectively, studies for the left and right halves of the final painting. From each, in turn, Léger derived a series of separate but related works, for instance, the painting *Woman with Cat* in the Florene May Schoenborn and Samuel A. Marx Collection.

The gouache by Giacomo Balla is the only futurist work in any medium in the collection of the Kröller-Müller Museum. In Italy, the futurists were frequently preoccupied with the rhythms of movement across the picture

plane. Balla's flock of birds in flight relates to paintings and other drawings on the same theme and is a recent acquisition from an American collection. In the Netherlands, the drawings by Bart van der Leck reflect the influence of cubism outside of France, specifically on de Stijl, a group of artists in the Netherlands organized by Theo van Doesburg in 1917. It included van der Leck and, of course, Piet Mondrian. Van der Leck's formal, painted abstractions were developed from detailed studies after nature. His progression to abstraction may seem schematic but the derivation of his straight lines and right angles may be logically traced from his drawings. Van der Leck is represented in the Kröller-Müller collection by almost four hundred works on paper.

In addition to the collection of drawings of the late nineteenth and early twentieth centuries, the Kröller-Müller Museum has three other special holdings of original works on paper. The first, about 850 sheets, consists of older drawings through the eighteenth century. A second collection, numbering several hundred sheets, consists of plans by architects, in particular H. P. Berlage, for projects and commissions initiated by Mrs. Kröller, whose chief concern increasingly became the housing and visual presentation of her collections. Together with earlier and later plans by Peter Behrens, Ludwig Mies van der Rohe, and Henry van de Velde, for the most part unfortunately owned elsewhere, and with designs for Mrs. Kröller's own homes and hunting lodge and their furnishings, these architectural drawings illustrate a fascinating chronicle of changing tastes in installation, ornament, and landscape gardening, and could be the subject of a separate publication.

A third special collection is devoted to drawings by sculptors. It reflects the continuing growth of the Kröller-Müller sculpture collection and was one of the particular interests of Professor A. M. Hammacher, former director of the museum. These drawings were acquired after Mrs. Kröller's death. For the most part, they complement additions to the sculpture collection made since World War II. Thus, a group of drawings by Julio Gonzalez was the gift of his daughter in 1955 on the occasion of the museum's acquisition of his early construction in iron, *Prayer*.

Drawings by sculptors such as Emile-Antoine Bourdelle, Reg Butler, Alberto Giacometti, Marino Marini, and Henry Moore are, in other examples, familiar to American audiences. Less well-known are two other European sculptors, the Dutch and Swiss artists Wessel Couzijn (born 1912), who once

worked in New York, and Bernhard Luginbühl (born 1929), who, in 1972, had a large retrospective at the Museum of Modern Art in Berlin. The drawing by Couzijn is for an unexecuted monument that was to have been erected in Rotterdam to commemorate the Dutch Merchant Marines killed in World War II. The drawing by Luginbühl is for a mobile construction in metal which, in 1967, was temporarily installed in the Kröller-Müller Museum's spacious outdoor sculpture park.

The selection of drawings reproduced on the following pages does not in any way attempt a broad survey of draftsmanship in Europe since 1875. It does, however, introduce to an American audience many drawings from a fascinating collection too little known.

W.S.L.

DRAWINGS

BY VAN GOGH

van Gogh: *Woman Grinding Coffee.* 1881. Pen and ink, pencil, and watercolor, heightened with gouache, 22⅛ x 15⅜ inches

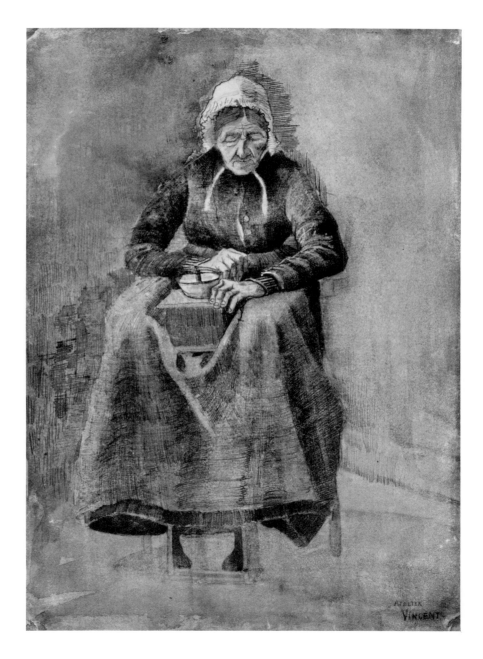

van Gogh: *The Paddemoes,
the Jewish Quarter of The
Hague.* 1882. Pen and ink and
pencil, 9⅞ x 12¼ inches

Opposite

van Gogh: *View of a Carpen-
ter's Workshop.* 1882. Pen and
brush and ink, and pencil,
heightened with gouache,
11⅜ x 18½ inches

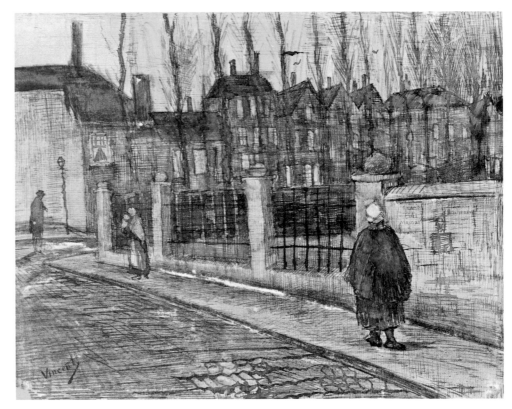

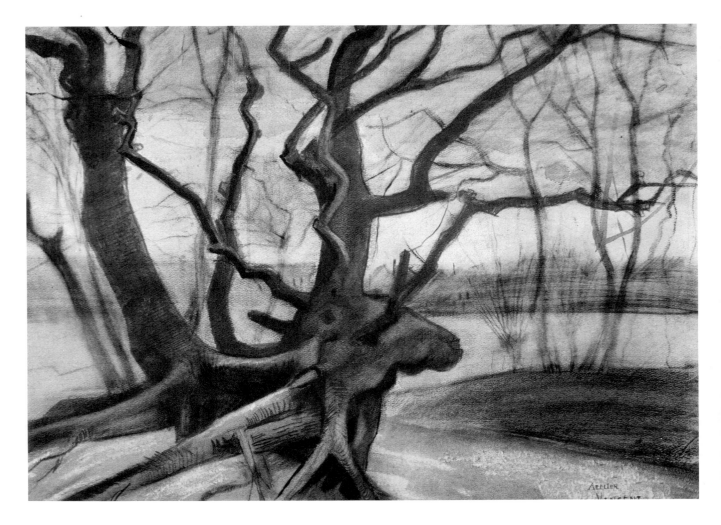

van Gogh: *Women Carrying Sacks.* 1882. Watercolor, heightened with gouache, 12⅝ x 19⅞ inches

Opposite

van Gogh: *Study of a Tree.* 1882. Chalk, watercolor, and pencil, 20¼ x 27⅝ inches

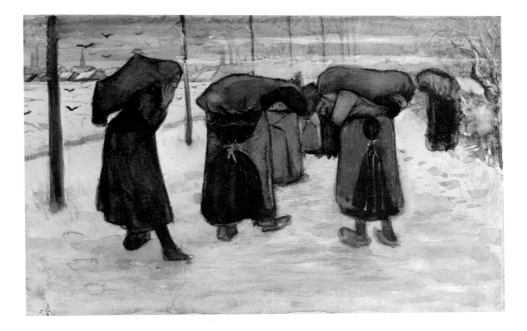

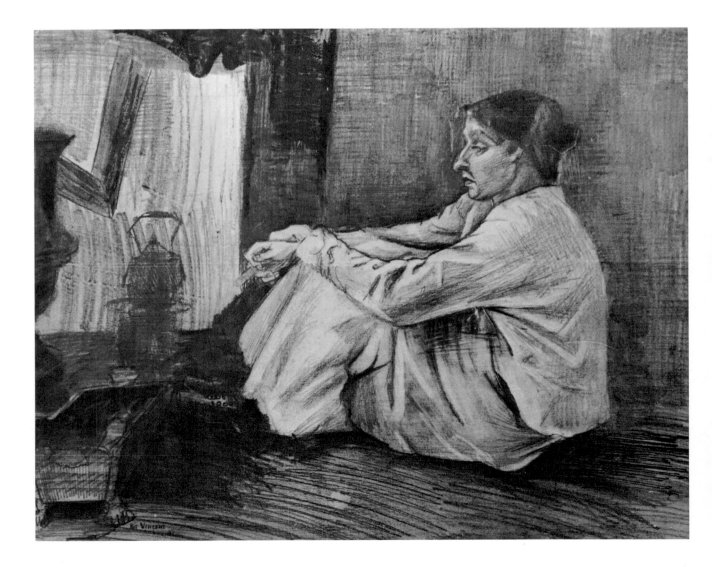

van Gogh: *The Forge*. 1882.
Pen and ink and pencil,
heightened with gouache,
14⅝ x 10⅜ inches

Opposite

van Gogh: *Sien with a Cigar*.
1882. Pencil, and pen and
brush and ink, heightened
with chalk, 17⅞ x 22 inches

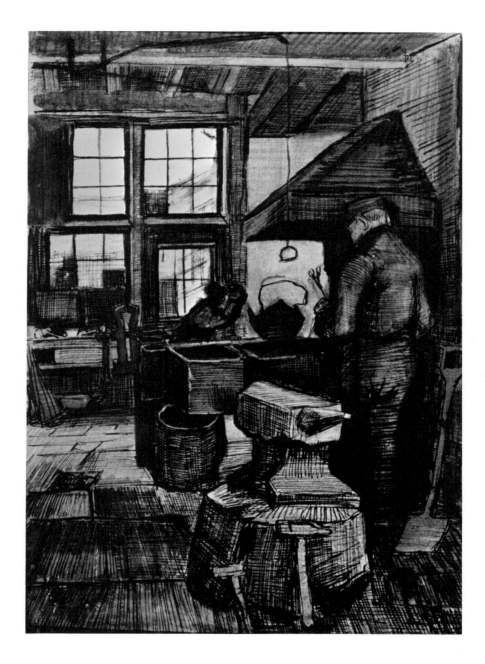

van Gogh: *Fisherman with a Pipe*. 1883. Pen and brush and ink, chalk, pencil, and gouache, 18 x 10⅜ inches

Opposite

van Gogh: *Woman Digging*. 1885. Chalk, 13¾ x 8¼ inches

van Gogh: *Man Reaping* 1885. Chalk, heightened with gouache, 22⅛ x 15 inches

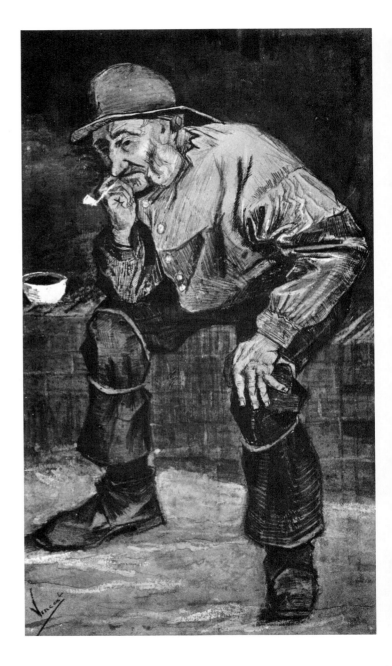

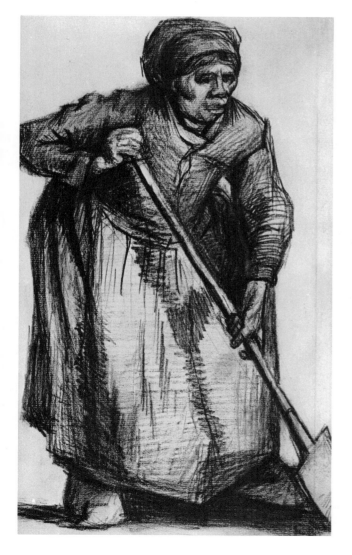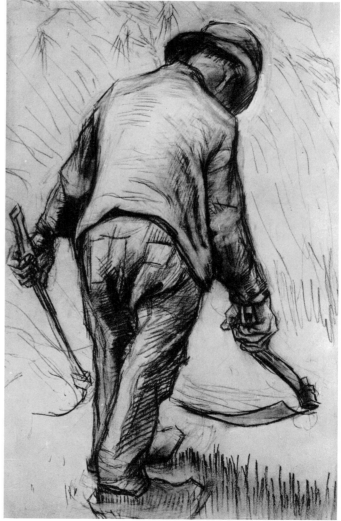

van Gogh: *Canal with Washerwomen*. 1888. Reed pen and ink, 12⅝ x 9⅝ inches

Opposite

van Gogh: *Wheat Field*. 1889. Chalk and reed pen and ink, heightened with gouache, 18⅝ x 22¼ inches

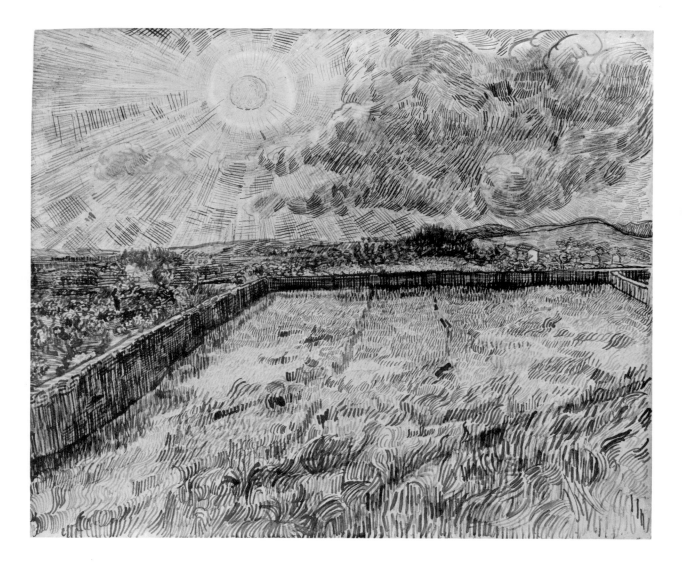

33

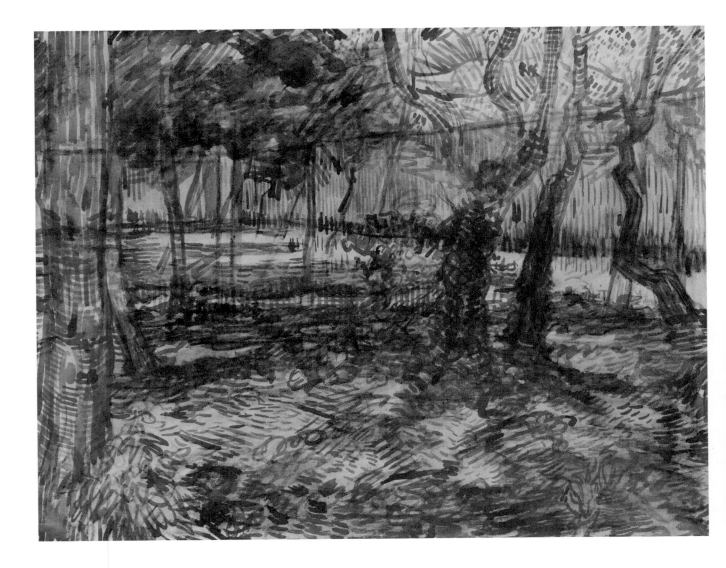

van Gogh: *Cypresses with Two Women*. 1889. Reed pen and ink, chalk, and touches of oil, 12⅝ x 9½ inches

Opposite

van Gogh: *A Corner of the Garden at the Hospital of St. Paul de Mausole*. 1889. Charcoal and brush and ink, 18⅜ x 23⅝ inches

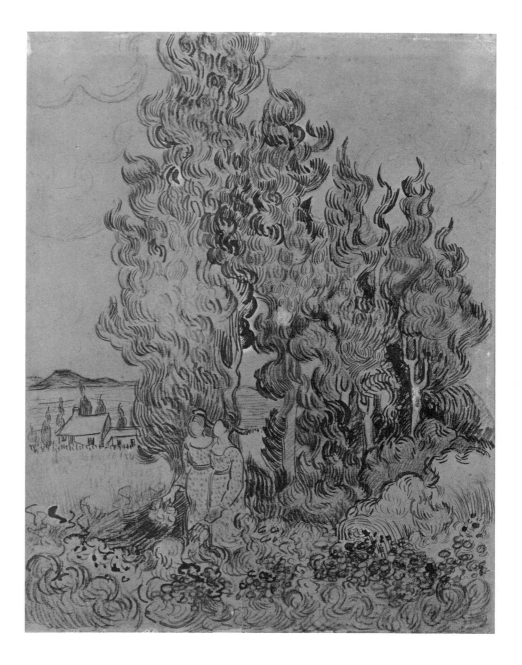

VAN GOGH
AND SOME
OF HIS DUTCH
CONTEMPORARIES

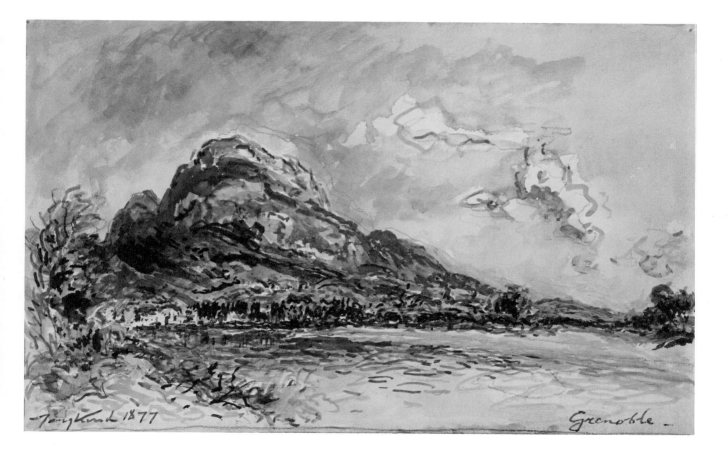

Jongkind 1877 Grenoble

van Gogh: *Woman by a Hearth*. 1885. Pen and brush and ink, 3⅞ x 5¼ inches

Jozef Israëls: *Woman Drinking Coffee*. Ca. 1900. Chalk, 8 x 13⅛ inches

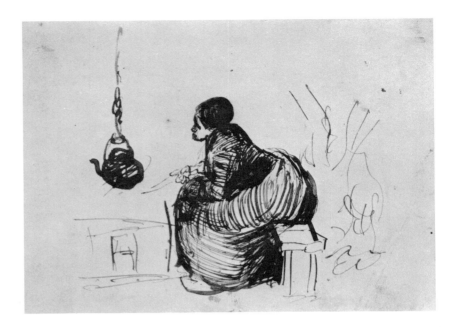

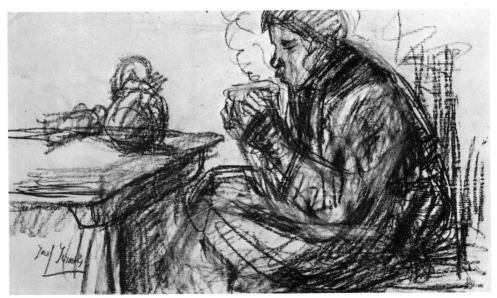

Blommers: *Woman by a Hearth.* Ca. 1906. Charcoal, 10⅛ x 7⅞ inches

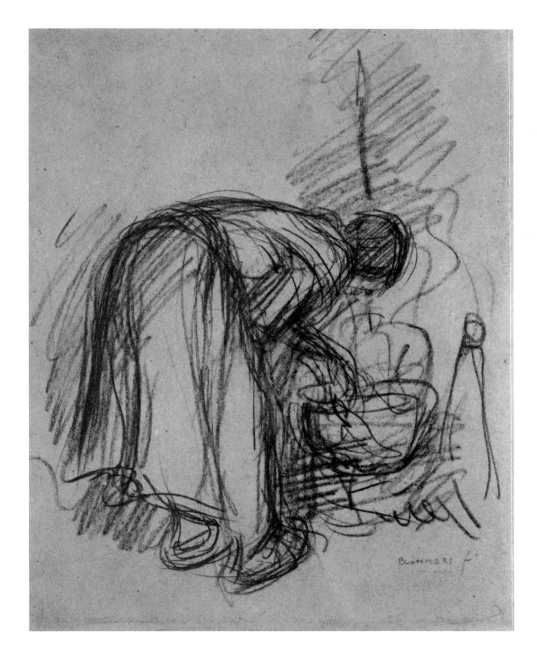

Rappard: *Pollard Birches.*
1884. Chalk and crayon,
9⅜ x 14 inches

Opposite

van Gogh: *The House of a
Railway Attendant.* 1881.
Charcoal and pencil,
17⅜ x 23½ inches

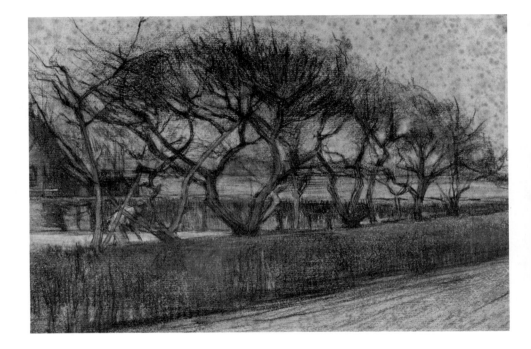

Allebé: *Man with an Um-
brella.* Ca. 1867. Charcoal and
white chalk, 19½ x 10¾
inches

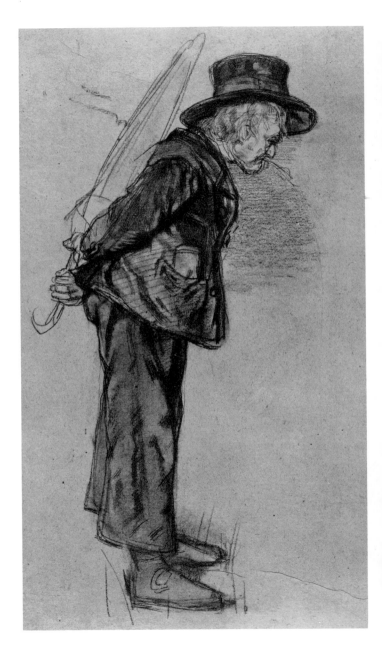

van Gogh: *Almsman with an Umbrella.* 1882. Pencil and charcoal, 19⅛ x 9¾ inches

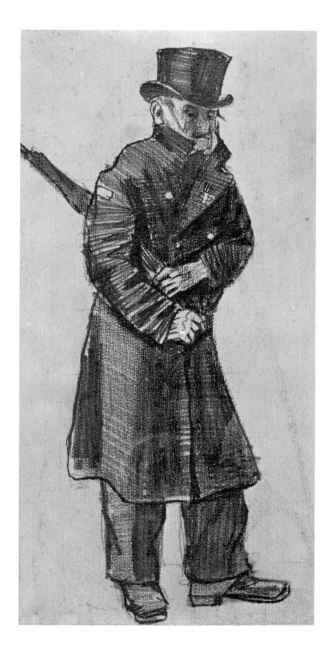

44

van Gogh: *A Cottage in the
Heath.* 1883. Pen and ink and
wash, 8⅞ x 11½ inches

Opposite

Verster: *Endegeest.* 1893.
Pastel, 17 x 26½ inches

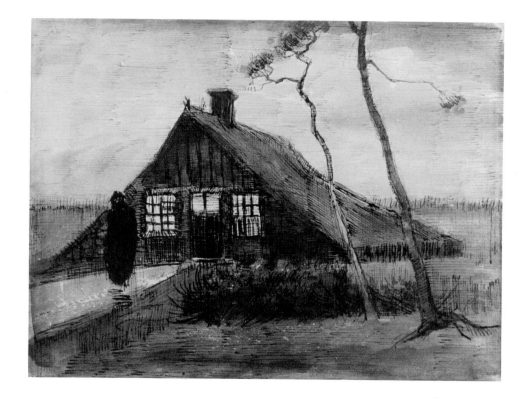

Breitner: *Lady with a Muff.*
Ca. 1888. Crayon, 13½ x 8¾
inches

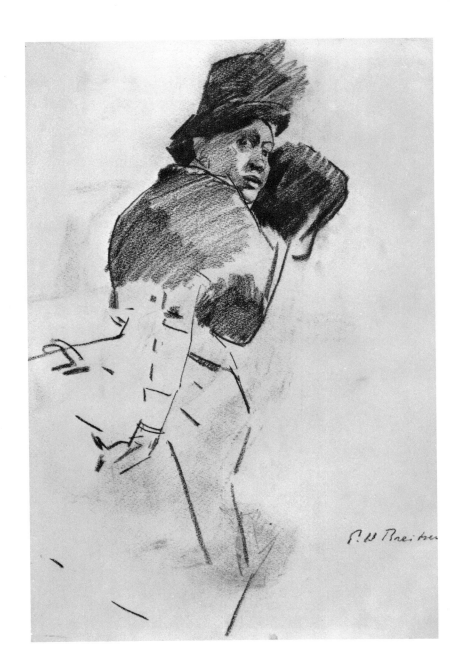

van Gogh: *Woman Seated on an Overturned Basket.* 1883. Crayon and chalk, 18¾ x 11⅝ inches

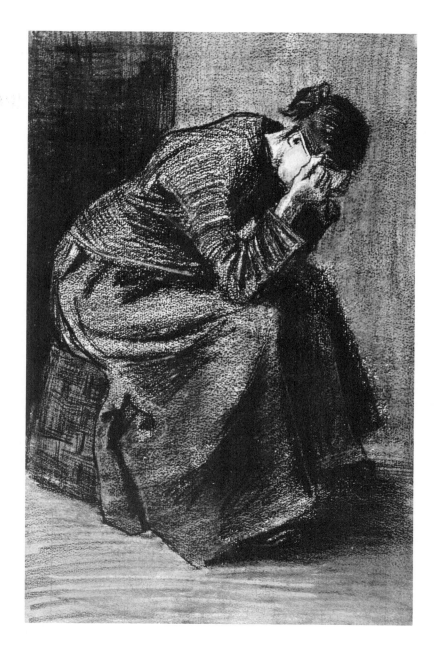

SYMBOLISM

AND

ART NOUVEAU

van de Velde:
Fruit and Vine.
1892–93. Pastel,
18⅞ x 19⅞
inches

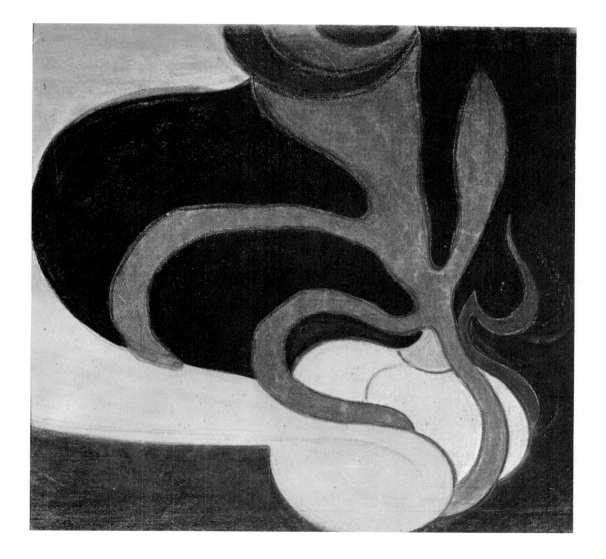

Redon: *Head of a Martyr.*
1877. Charcoal, 14½ x 14⅜
inches

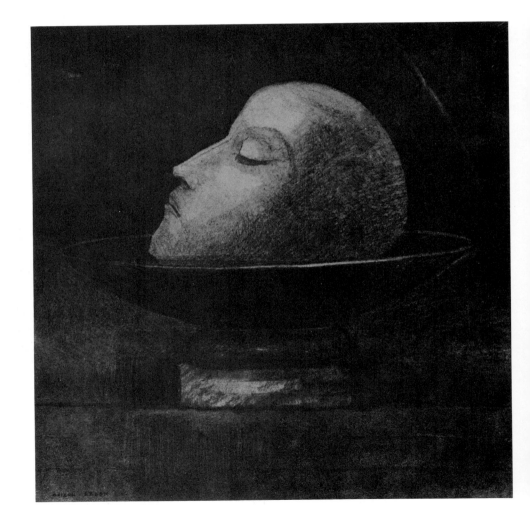

Redon: *The Marsh Flower.*
1880–81. Charcoal, 19⅝ x 13½
inches

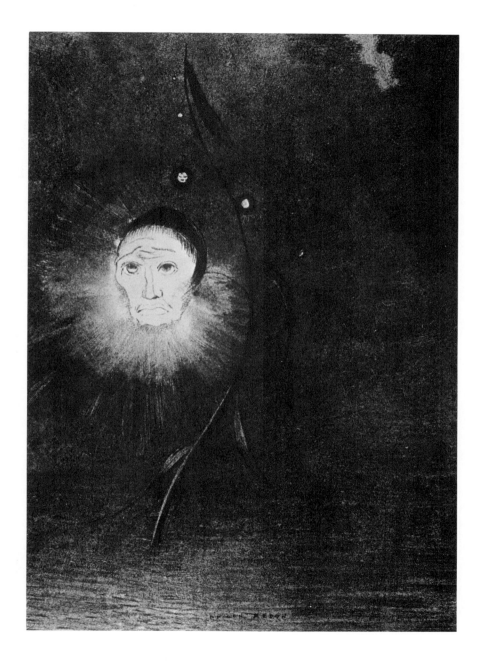

Redon: *Woman in Profile.*
1890–95. Charcoal, 17⅝ x
14¾ inches

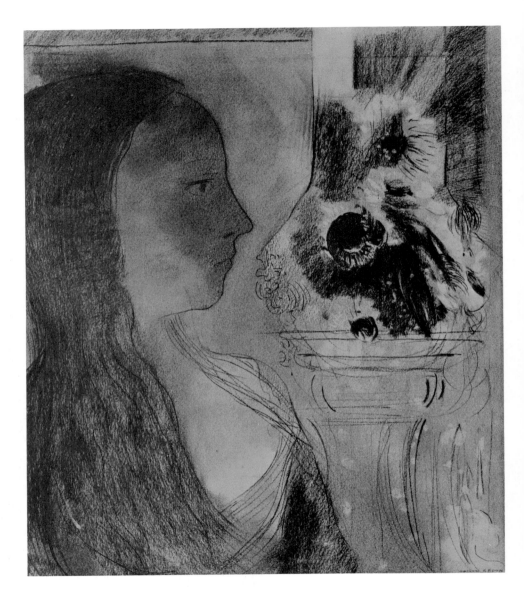

Redon: *Woman and Serpent.*
1885–90. Charcoal, 20⅝ x
14¾ inches

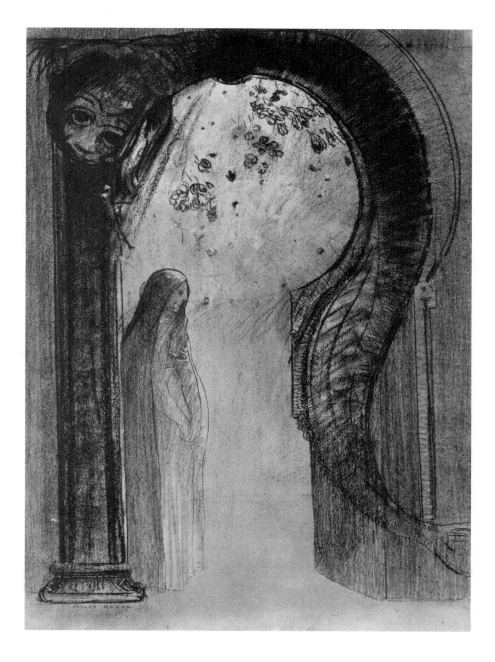

Degouve de Nuncques: *The Black Swan*. 1896. Pastel, 13⅞ x 17⅝ inches

Opposite

Degouve de Nuncques: *Park in Milan*. 1895. Pastel, 18⅜ x 29½ inches

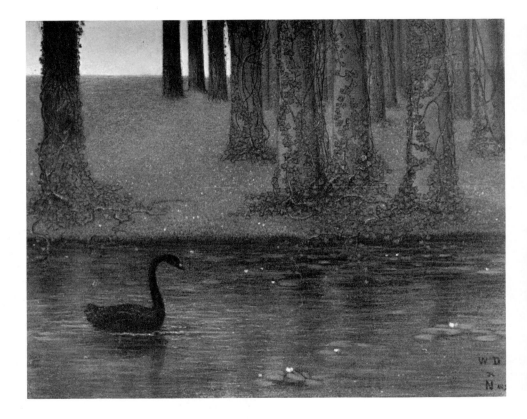

Toorop: *Fatality*. 1893. Crayon
and pencil, heightened with
chalk, 23⅝ x 29¾ inches

Opposite

Toorop: *The Three Brides*.
1893. Crayon and pencil,
heightened with gouache,
30⅝ x 39¼ inches

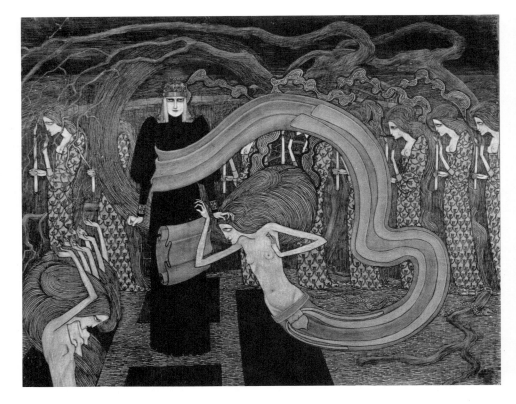

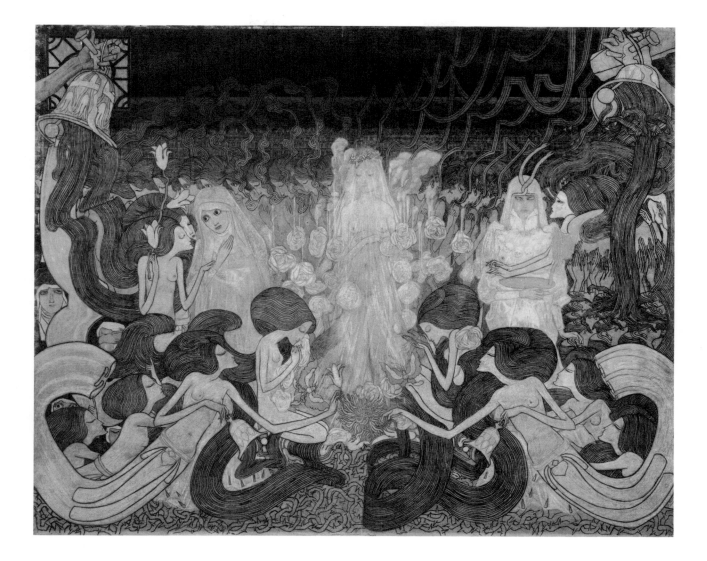

Signac: *A Time of Concord.*
1895. Chalk, 13⅛ x 13¾
inches

Opposite

Khnopff: *The Offering.* 1891.
Crayon, 5⅝ x 4⅞ inches

Rops: *Flora.* n.d. Watercolor,
gold lacquer, and pencil,
9⅝ x 7⅛ inches

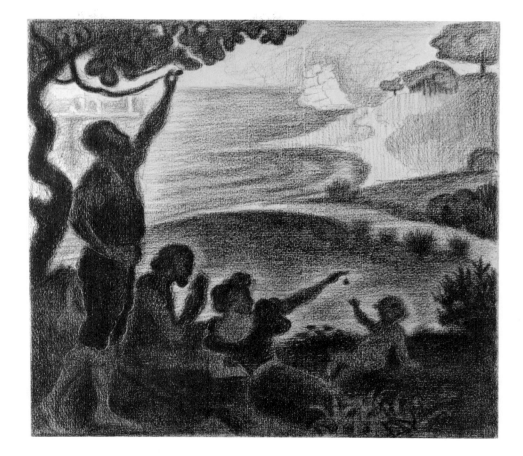

van de Velde: *Girl in a Farm-yard.* 1891. Chalk, 18¼ x 19⅜ inches

Opposite

Thorn Prikker: *Haystacks.* Ca. 1904. Crayon and water-color, 19 x 23 inches

CUBISM, FUTURISM, AND DE STIJL

Balla: *The Flight of Swifts.* 1913. Gouache, 19½ x 29¼ inches

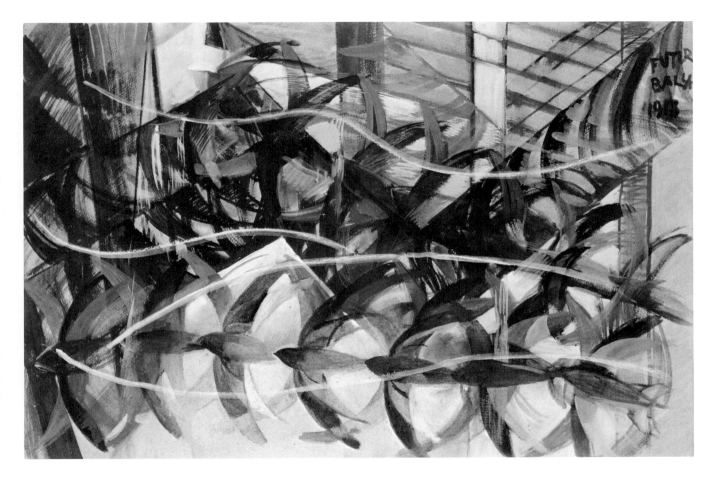

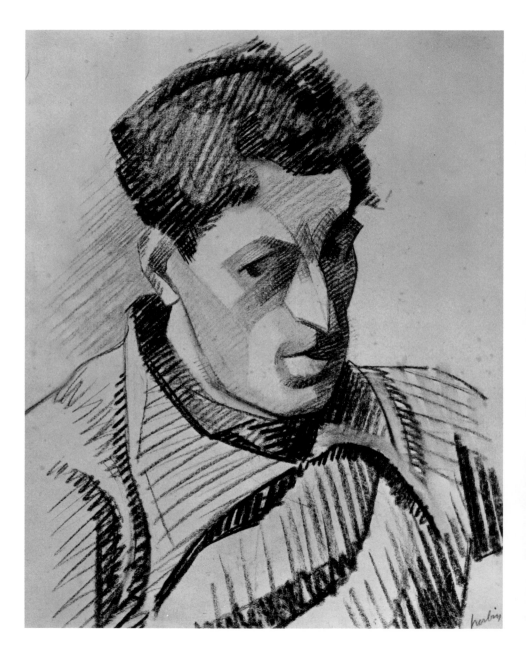

Herbin: *Self Portrait.* 1909.
Chalk, 21½ x 16½ inches

Picasso: *Standing Nude.* 1908.
Gouache, 25⅜ x 19⅜ inches

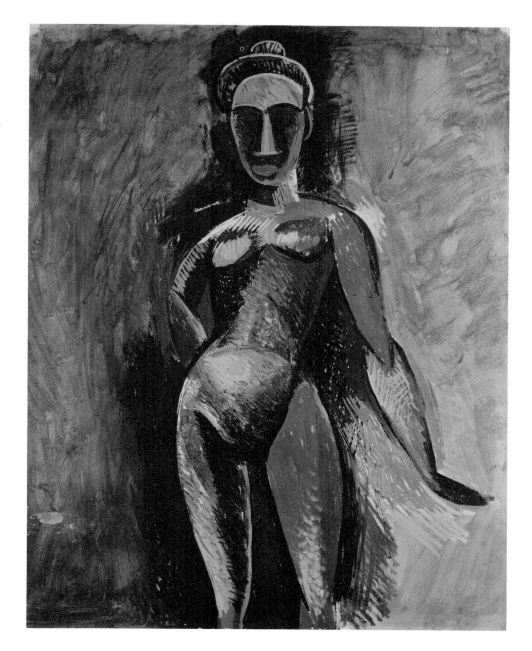

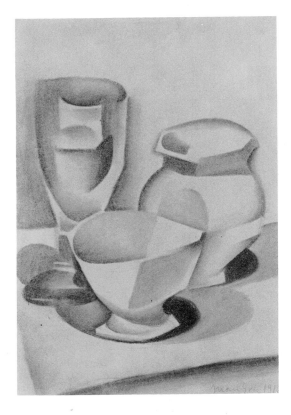

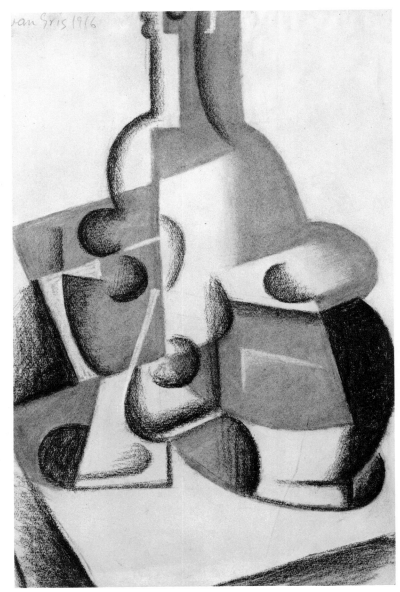

Gris: *Bottle, Glass, Fruit Bowl, and Newspaper.* 1916. Crayon, 18 x 11⅞ inches

Opposite

Gris: *Bowl, Glass, and Pitcher.* 1916. Chalk, 17⅛ x 11⅜ inches

Gris: *Bottle, Glass, and Pitcher.* 1916. Chalk, 18⅜ x 11⅝ inches

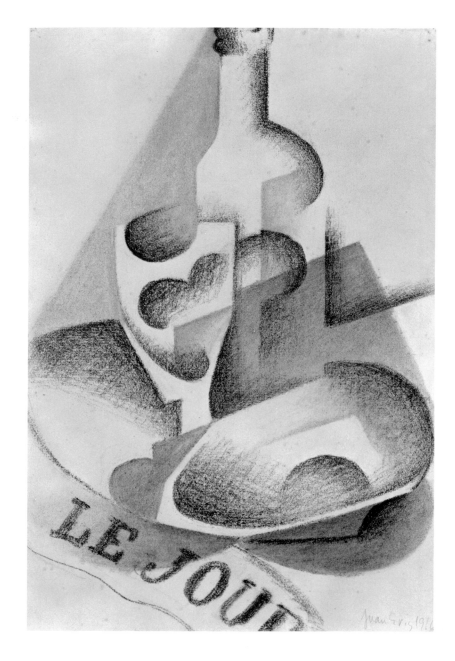

Gris: *Milk Bottle, Coffee Pot,*
and Sugar Bowl. 1918. Pencil,
18⅛ x 11⅝ inches

Opposite

Gris: *Fruit Bowl, Glass, and*
Newspaper. 1918. Pencil,
14⅛ x 21⅛ inches

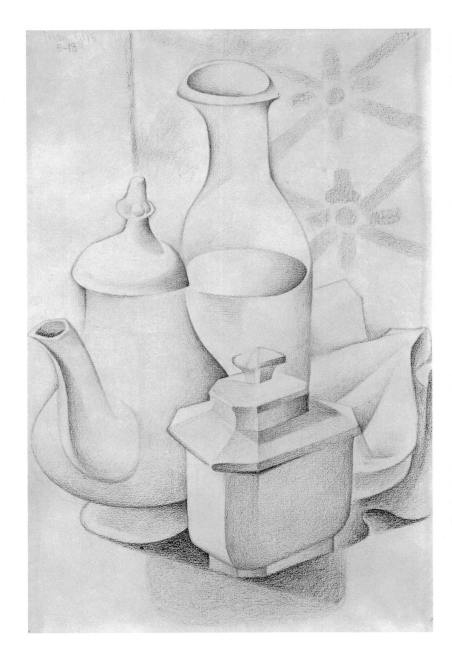

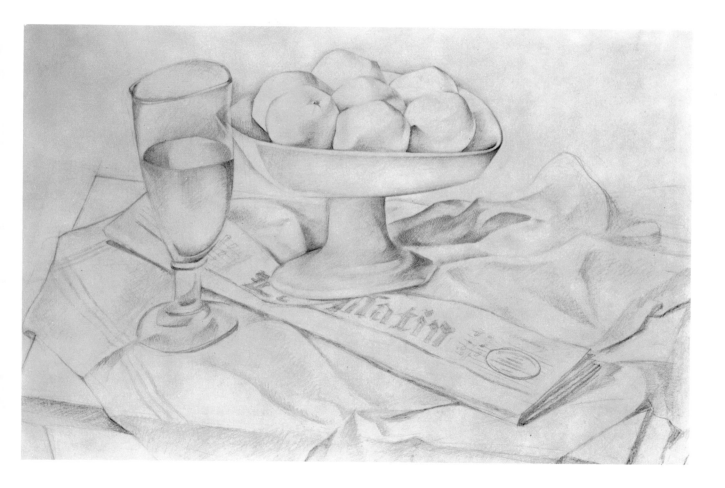

Léger: *Le Grand Déjeuner.*
1920. Pencil, 14½ x 20¼
inches

Opposite

Léger: *Two Reclining Nudes.*
1921. Pencil, 19⅜ x 14⅜
inches

Léger: *Seated Nude.* 1921.
Pencil, 18½ x 14 inches

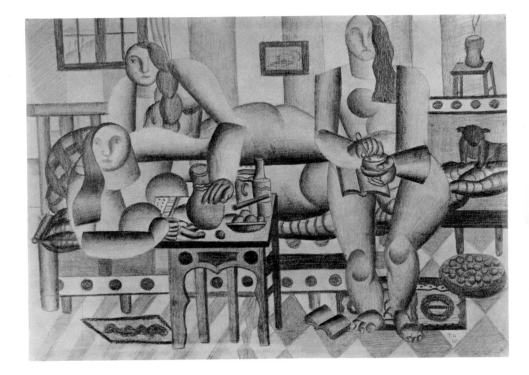

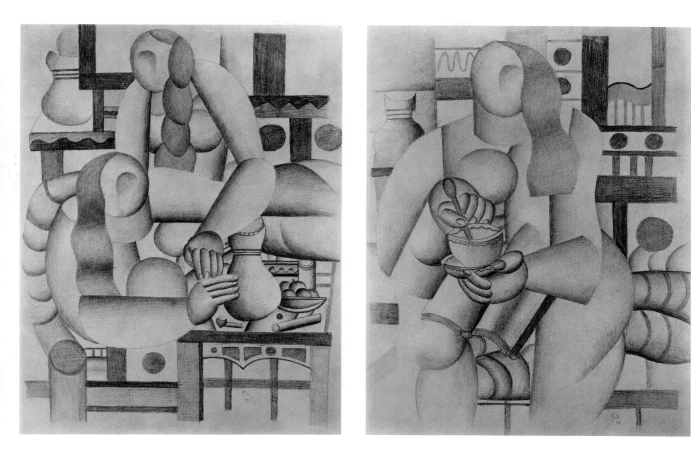

van der Leck: Study for the left
panel of the triptych *Mine
with Miners*. 1916. Gouache,
charcoal, and pencil, 24¾ x
44⅛ inches

Opposite

van der Leck: *Flowering
Branch*. 1921. Watercolor and
charcoal, 12⅜ x 17⅝ inches

van der Leck: *Wine Bottle and
Fruit Bowl*. 1922. Watercolor
and charcoal, 16 x 12¾ inches

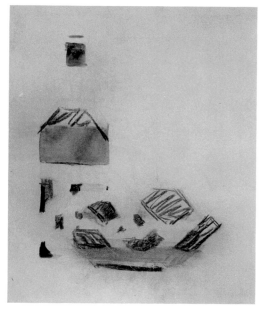

DRAWINGS
BY SCULPTORS

Bourdelle: *Rodin at Work.*
Ca. 1911. Pen and ink,
7⅜ x 9¼ inches

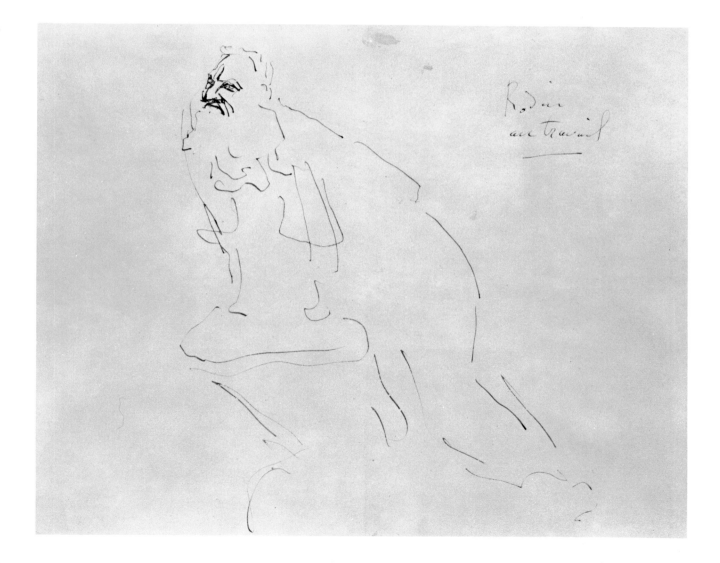

Rodin
au travail

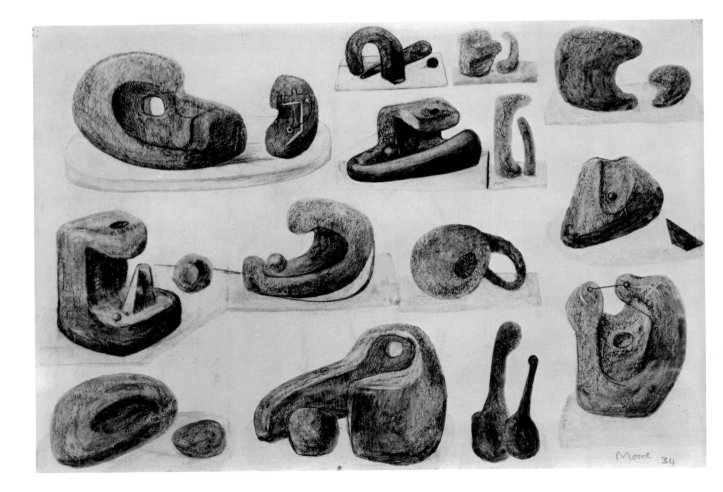

Giacometti: *The Sculptor's Studio.* 1958. Pencil, 18 x 11⅞ inches

Opposite

Moore: *Ideas for Sculpture.* 1934. Charcoal, ink wash, and watercolor, 14⅞ x 22 inches

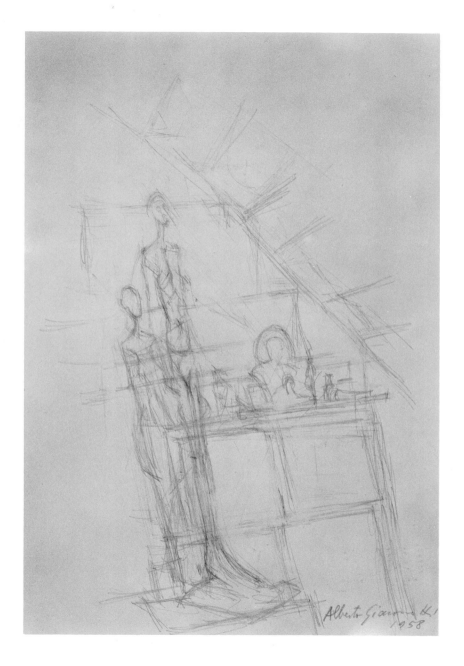

Gonzalez: *The Prophet*. 1941.
Pen and ink, ink wash, and
pencil, 14⅞ x 10⅜ inches

Opposite

Gonzalez: *Self Portrait*. 1940.
Wash and pencil, 9½ x 6¼
inches

Gonzalez: *Crying Woman*.
1941. Pen and ink, watercolor,
and pencil, 8 x 6⅛ inches

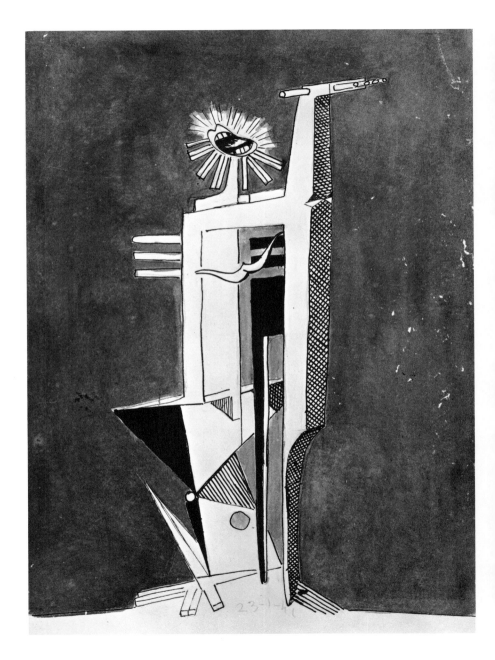

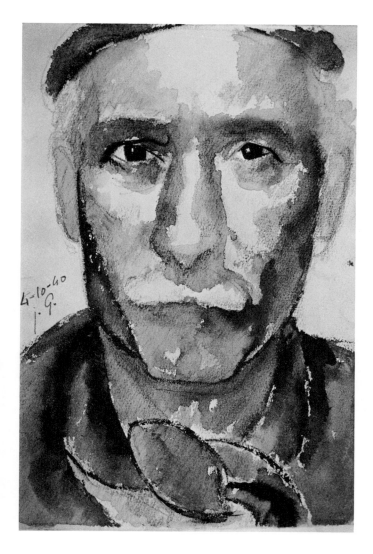

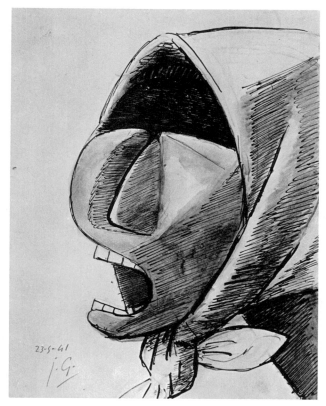

Marini: *Horse*. Ca. 1948.
Watercolor, pastel, and brush
and ink, 19½ x 13¼ inches

Opposite

Butler: Untitled. 1960. Pencil
and charcoal, 21⅝ x 30⅛
inches

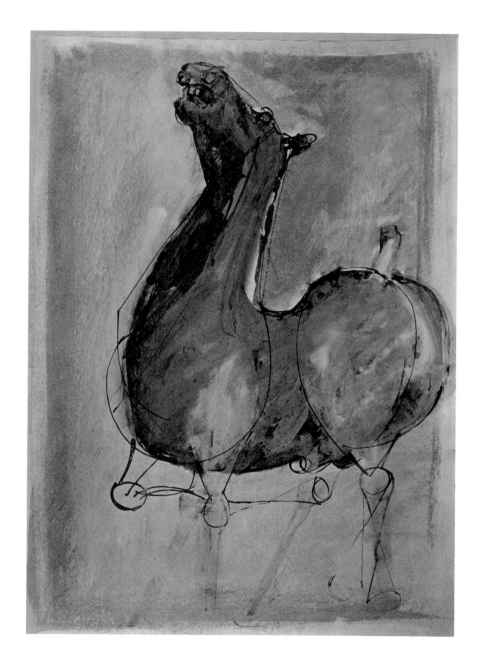

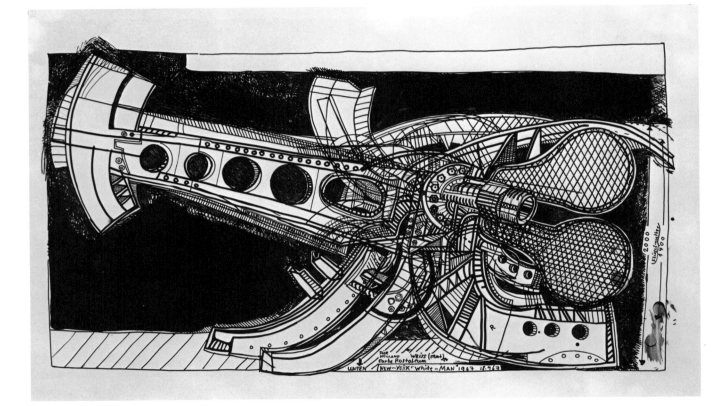

Couzijn: Study for a monument. 1951. Chalk, 29⅞ x 22¼ inches

Opposite

Luginbühl: *White Man.* 1967. Brush and pen and ink, 23⅛ x 40 inches

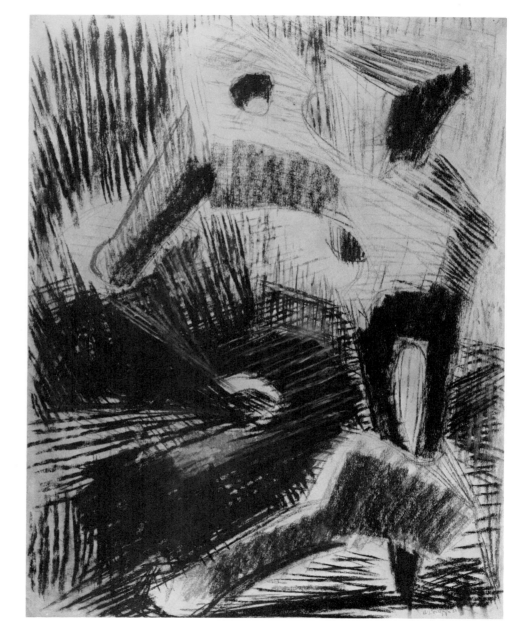

In the catalogue, dates enclosed in parentheses do not appear on the drawings themselves. All works are on paper. Sheet dimensions are given in inches and centimeters, height preceding width. In a few instances, sight measurements are given. The page on which a work is illustrated is given at the end of the entry. In the listing of works by van Gogh, "F." refers to the definitive catalogue, *The Works of Vincent van Gogh—His Paintings and Drawings*, by J.-B. de la Faille, revised edition published in 1971.

ALLEBÉ, AUGUST
Dutch, 1838–1927

1 *Man with an Umbrella.* (Ca. 1867). Charcoal and white chalk, 19½ x 10¾" (49.6 x 27.3 cm). Page 42

BALLA, GIACOMO
Italian, 1871–1958

2 *The Flight of Swifts.* 1913. Gouache, 19½ x 29¼" (50 x 74.2 cm) (sight). Page 63

BLOMMERS, BERNARDUS
JOHANNES
Dutch, 1845–1914

3 *Mill.* (Ca. 1906). Charcoal, crayon, and pastel, 6¼ x 9⅞" (15.8 x 25.1 cm)

4 *Woman by a Hearth.* (Ca. 1906). Charcoal, 10⅛ x 7⅞" (25.7 x 19.9 cm). Page 39

BOURDELLE, EMILE-ANTOINE
French, 1861–1929

5 *Isadora Duncan.* (Ca. 1911). Pen and ink, 9⅞ x 6⅜" (25 x 16.3 cm)

6 *Rodin at Work.* (Ca. 1911). Pen and ink, 7⅜ x 9¼" (18.5 x 23.4 cm). Page 75

BREITNER, GEORGE HENDRIK
Dutch, 1857–1923

7 *Lady with a Muff.* (Ca. 1888). Crayon, 13½ x 8¾" (34.1 x 22.2 cm). Page 46

8 *Two Women.* (1892–93). Watercolor and pencil, 18⅛ x 11⅛" (46.1 x 28.1 cm)

BREMMER, HENDRIK P.
Dutch, 1871–1956

9 *Neighborhood Houses.* 1894. Oil, 5⅛ x 6¼" (13.1 x 15.9 cm)

BREMMER, RUDOLF
Dutch, born 1900

10 *Floris Hendrik Verster.* 1923. Crayon, 17⅞ x 11" (45.5 x 27.9 cm)

BUTLER, REG
British, born 1913

11 Untitled. 1960. Pencil and charcoal, 21⅝ x 30⅛" (55.2 x 76.2 cm). Page 80

CHAGALL, MARC
French, born Russia 1887

12 *Bride and Groom.* 1909. Pen and ink, 7¼ x 9¾" (18.3 x 24.9 cm) (irreg.)

COUZIJN, WESSEL
Dutch, born 1912

13 Study for a projected monument in memory of the Merchant Marines killed in World War II. 1951. Chalk, 29⅞ x 22¼" (75.8 x 56.3 cm). Page 83

CROP, MICHIEL DUCO
Dutch, 1863–1901

14 *Tiger Lily.* 1893. Watercolor, and pen and brush and ink, 10⅞ x 11⅞" (27.7 x 30.2 cm)

DEGOUVE DE NUNCQUES, WILLIAM
Belgian, 1867–1935

15 *Park in Milan.* 1895. Pastel, 18⅜ x 29½" (46.4 x 74.9 cm). Page 55

16 *Stairs in Venice.* 1895. Pastel, 20½ x 29⅝" (52.1 x 75.7 cm)

17 *The Black Swan.* 1896. Pastel, 13⅞ x 17⅝" (35.4 x 44.8 cm) (sight). Page 54

FANTIN-LATOUR, HENRI
French, 1836–1904

18 *The Drawing Lesson.* 1879. Crayon, 15⅝ x 18⅜" (39.7 x 46 cm)

GIACOMETTI, ALBERTO
Swiss, 1901–1966
Worked in France

19 *The Sculptor's Studio.* 1958. Pencil, 18 x 11⅞" (45 x 30 cm). Page 77

VAN GOGH, VINCENT
Dutch, 1853–1890

20 *The Milk Jug.* (Zundert, 5 September 1862). Charcoal, pencil, and wash, 11 x 8¾" (28 x 22.1 cm). F.-(J.) III

21 *A Sower.* (Etten, September 1881). Pencil, chalk, and wash, heightened with gouache, 24⅛ x 17¾" (61.3 x 45 cm). F. 862

22 *Windmills on the Weeskinderendijk, at Dordrecht.* (Etten, early Autumn 1881). Watercolor, pencil, crayon, and chalk, heightened with gouache, 10¼ x 23¾" (26.3 x 60 cm). F. 850

23 *Boy with a Sickle.* (Etten, October 1881). Chalk, watercolor, and gouache, 18⅜ x 24" (46.9 x 60.8 cm). F. 851

24 *Man Sweeping.* (Etten, October 1881). Chalk, crayon, and watercolor, heightened with gouache, 22 x 11" (55.8 x 27.8 cm). F. 890

25 *Man Reading by a Fire.* (Etten, late October 1881). Charcoal, crayon, chalk, watercolor, and gouache, 17¾ x 22" (44.8 x 55.9 cm). F. 897

26 *Woman Grinding Coffee.* (Etten, October–November 1881). Pen and ink, pencil, and watercolor, heightened with gouache, 22⅛ x 15⅜" (56 x 38.8 cm). F. 889. Page 23

27 *The House of a Railway Attendant.* (Etten, late Autumn 1881). Charcoal and pencil, 17⅜ x 23½" (43.9 x 59.6 cm). F. 900. Page 41

28 *Old Man Kindling Wood.* (Etten, November 1881). Crayon, chalk, gouache, and wash, 22⅛ x 17¾" (56.1 x 45.1 cm). F. 868

29 *Old Woman Sewing.* (Etten, November 1881). Charcoal, chalk, and watercolor, heightened with gouache, 24¾ x 18¾" (62.9 x 47.6 cm). F. 1221

30 *The Paddemoes, the Jewish Quarter of The Hague.* (February–March 1882). Pen and ink and pencil, 9⅞ x 12¼" (25.2 x 30.9 cm). F. 918. Page 24

31 *The Forge.* (The Hague, March 1882). Pen and ink and pencil, heightened with gouache, 14⅝ x 10⅜" (37 x 26.2 cm). F. 1084. Page 29

32 *Sien Resting.* (The Hague, April 1882). Pencil, pen and brush and ink, and watercolor, 23 x 17" (58.4 x 43.1 cm). F. 937.

33 *Sien with a Cigar.* (The Hague, April 1882). Pencil, and pen and brush and ink, heightened with chalk, 17⅞ x 22" (45.2 x 55.9 cm) (irreg.). F. 898. Page 28

34 *Study of a Tree.* (The Hague, April 1882). Chalk, watercolor, and pencil, 20¼ x 27⅝" (51.2 x 70.1 cm). F. 933. Page 26

35 *Fish-Drying Barn at Scheveningen.* (The Hague, May 1882). Pen and brush and ink, and pencil, heightened with gouache, 11⅝ x 18" (29.4 x 45.4 cm). F. 938

36 *View of a Carpenter's Workshop.* (The Hague, May 1882). Pen and brush and ink, and pencil, heightened with gouache, 11⅜ x 18½" (28.8 x 47 cm). F. 939. Page 25

37 *Almsman with an Umbrella.* (The Hague, September–December 1882). Pencil and charcoal, 19⅛ x 9¾" (48.4 x 24.7 cm). F. 972. Page 43

38 *Women Carrying Sacks.* (The Hague, October–November 1882). Watercolor, heightened with gouache, 12⅝ x 19⅞" (32.1 x 50.4 cm). F. 994. Page 27

39 *Man Reading a Bible.* (The Hague, December 1882). Pencil, 18⅝ x 11⅞" (47.3 x 30.3 cm). F. 1001

40 *Man with a Pipe.* (The Hague, December 1882). Lithographic crayon and pencil, heightened with gouache, 17¾ x 10⅞" (44.9 x 27.5 cm). F. 1004. Frontispiece

41 *Girl with a Shawl.* (The Hague, January 1883). Chalk and pencil, heightened with gouache, 17¼ x 10" (43.4 x 25.4 cm). F. 1007

42 *Woman Seated on an Overturned Basket.* (The Hague, March–April 1883). Crayon and chalk, 18¾ x 11⅝" (47.4 x 29.5 cm). F. 1060. Page 47

43 *Fisherman with a Pipe.* (The Hague, July 1883). Pen and brush and ink, chalk, pencil, and gouache, 18 x 10⅜" (45.5 x 26.3 cm). F. 1010. Page 30

44 *A Cottage in the Heath.* (Drenthe, October–November 1883). Pen and ink and wash, 8⅞ x 11½" (22.5 x 29.2 cm). F. 1097. Page 45

45 *A Weaver.* (Nuenen, April–May 1884). Pen and ink, wash, and pencil, heightened with gouache, 10⅞ x 15¾" (27.4 x 40 cm). F. 1134

46 *Woman by a Hearth.* (Nuenen, May 1885). Pen and brush and ink, 3⅞ x 5¼" (9.9 x 3.4 cm). F. 1291. Page 38

47 *Woman Digging.* (Nuenen, June–August 1885). Chalk, 13¾ x 8¼" (35 x 21 cm). F. 1254. Page 31

48 *Woman Binding Sheaves.* (Nuenen, July–August 1885). Chalk and crayon, heightened with gouache, 17⅝ x 23″ (44.8 x 58.5 cm). F. 1262

49 *Man Reaping.* (Nuenen, August 1885). Chalk, heightened with gouache, 22⅛ x 15″ (56.2 x 37.9 cm) (irreg.). F. 1313. Page 31

50 *Man Reaping Wheat.* (Nuenen, August 1885). Chalk, 16½ x 22″ (41.9 x 57 cm). F. 1322 verso.

51 *The Graveyard.* (Paris, 1886). Pen and brush and ink, chalk, and pencil, 14½ x 19⅛″ (36.8 x 48.5 cm). F. 1399a

52 *Canal with Washerwomen (La Roubine du Roi).* (Arles, June 1888). Reed pen and ink, 12⅝ x 9⅝″ (32 x 24.5 cm). F. 1444. Page 32

53 *Flowers in the Garden of the Hospital of St. Paul de Mausole.* (St. Rémy, May–June 1889). Watercolor, 24¼ x 18½″ (61.6 x 46.9 cm). F. 1527

54 *Cypresses with Two Women.* (St. Rémy, June 1889). Reed pen and ink, chalk, and touches of oil, 12⅝ x 9½″ (32 x 23.9 cm). F. 1525a. Cover, page 35

55 *A Corner of the Garden at the Hospital of St. Paul de Mausole.* (St. Rémy, July 1889). Charcoal and brush and ink, 18⅜ x 23⅝″ (46.5 x 60.1 cm). F. 1505. Page 34

56 *Wheat Field.* (St. Rémy, Autumn 1889). Chalk and reed pen and ink, heightened with gouache, 18⅝ x 22¼″ (47.5 x 56.5 cm) (irreg.). F. SD-1728. Page 33

GONZALEZ, JULIO
Spanish, 1876–1942
Worked in France

57 *Self Portrait.* 4 October 1940. Wash and pencil, 9½ x 6¼″ (24 x 15.8 cm). Gift of Mme Roberta Gonzalez, 1955. Page 79

58 *The Prophet.* 23 January 1941. Pen and ink, ink wash, and pencil, 14⅞ x 10⅜″ (37.6 x 26.4 cm). Gift of Mme Roberta Gonzalez, 1955. Page 78

59 *Crying Woman, The Montserrat.* 23 May 1941. Pen and ink, watercolor, and pencil, 8 x 6⅛″ (20.4 x 15.6 cm). Gift of Mme Roberta Gonzalez, 1955. Page 79

GRIS, JUAN
Spanish, 1887–1927
Worked in France

60 *Bottle, Glass, and Pitcher.* 1916. Chalk, 18⅜ x 11⅝″ (46.6 x 29.6 cm). Page 66

61 *Bottle, Glass, Fruit Bowl, and Newspaper.* 1916. Crayon, 18 x 11⅞″ (45.7 x 30.1 cm). Page 67

62 *Bowl, Glass, and Pitcher.* 1916. Chalk, 17⅛ x 11⅜″ (43.5 x 28.9 cm). Page 66

63 *Milk Bottle, Coffee Pot, and Sugar Bowl.* May 1918. Pencil, 18⅛ x 11⅝″ (46.1 x 29.6 cm). Page 68

64 *Fruit Bowl, Glass, and Newspaper.* (1918). Pencil, 14⅛ x 21⅛" (36 x 53.5 cm). Page 69

HERBIN, AUGUSTE
French, 1882–1960

65 *Self Portrait.* (1909). Chalk, 21½ x 16½" (54.4 x 41.7 cm). Page 64

ISRAËLS, ISAÄC L.
Dutch, 1865–1934

66 *Man in a Top Hat.* (1906). Chalk, 13½ x 8⅞" (34.3 x 22.5 cm)

ISRAËLS, JOZEF
Dutch, 1824–1911

67 *Woman Drinking Coffee.* (Ca. 1900). Chalk, 8 x 13⅛" (20.1 x 33.1 cm). Page 38

JONGKIND, JOHAN BARTHOLD
Dutch, 1819–1891

68 *Landscape near Grenoble.* 1877. Watercolor and charcoal, 9 x 14⅛" (22.8 x 35.9 cm). Page 37

KHNOPFF, FERNAND
Belgian, 1858–1921

69 Study for *The Offering.* 1891. Crayon, 5⅝ x 4⅞" (14.2 x 12.2 cm). Page 58

VAN DER LECK,
BART ANTHONY
Dutch, 1876–1958

70 *Evening: A Small Canal.* 1908. Watercolor, charcoal, and pencil, 14⅞ x 18¾" (37.7 x 47.5 cm)

71 Study for the left panel of the triptych *Mine with Miners.* (1916). Gouache, charcoal, and pencil, 24¾ x 44⅛" (62.8 x 102.1 cm) (sight). Page 72

72 *Flowering Branch.* (1921). Watercolor and charcoal, 12⅜ x 17⅝" (31.2 x 44.7 cm). Page 73

73 *Wine Bottle and Fruit Bowl.* (1922). Watercolor and charcoal, 16 x 12¾" (40.6 x 32.3 cm). Page 73

74 *Elephant.* (1923). Charcoal, 11⅜ x 14⅛" (28.7 x 35.7 cm)

75 *Elephant.* (1923). Watercolor, gouache, and charcoal, 13¼ x 15¼" (33.6 x 38.4 cm)

76 *Two Trees.* 1923. Charcoal, 20⅛ x 17⅜" (51.2 x 44.1 cm)

LÉGER, FERNAND
French, 1881–1955

77 *Le Grand Déjeuner.* 1920. Pencil, 14½ x 20¼" (37 x 51.4 cm). Page 70

78 *Seated Nude,* study for *Le Grand Déjeuner.* 1921. Pencil, 18½ x 14" (46.9 x 35.5 cm). Page 71

79 *Two Reclining Nudes,* study for *Le Grand Déjeuner.* 1921. Pencil, 19⅜ x 14⅜" (49 x 36.5 cm). Page 71

LUGINBÜHL, BERNHARD
Swiss, born 1929

80 *White Man.* 1967. Brush and pen and ink, 23⅛ x 40" (58.7 x 101.4 cm). Page 82

MARINI, MARINO
Italian, born 1901

81 *Horse.* (Ca. 1948). Watercolor, pastel, and brush and ink, 19½ x 13¼" (49.4 x 33.8 cm). Page 81

MAUVE, ANTON
Dutch, 1838–1888

82 *A Flock of Sheep.* (Ca. 1886). Crayon, 5 x 9⅛" (12.5 x 23.7 cm)

MONDRIAN, PIET
Dutch, 1872–1944

83 *Branch of Lilies.* (Ca. 1907) Charcoal, 12⅛ x 8¼" (31 x 21 cm)

MOORE, HENRY
British, born 1898

84 *Ideas for Sculpture.* 1934. Charcoal, ink wash, and watercolor, 14⅞ x 22" (37.9 x 55.8 cm). Page 76

NIJLAND, DIRK H.
Dutch, 1881–1955

85 *The Ferry.* 1905. Crayon, 15⅛ x 20" (38.4 x 50.8 cm)

86 *The Ferry.* (1906). Pen and ink, 7½ x 8¼" (18.5 x 20.9 cm)

87 *Man on a Ferry.* (1906). Pen and ink, 10¼ x 4⅞" (26 x 12.2 cm)

PICASSO, PABLO
Spanish, 1881–1973
Worked in France

88 *Standing Nude.* (1908). Gouache, 25⅜ x 19⅜" (64.2 x 49.1 cm). Page 65

RAEDECKER, JOHN A.
Dutch, 1885–1956

89 *Henry van de Velde.* 1943. Crayon, 17¾ x 13⅞" (44.9 x 35 cm)

RAPPARD, ANTON GERARD
ALEXANDER RIDDER VAN
Dutch, 1858–1892

90 *Pollard Birches.* (1884). Chalk and crayon, 9⅜ x 14" (23.7 x 35.3 cm). Page 40

REDON, ODILON
French, 1840–1916

91 *The Flight (Warrior on Horseback).* (Ca. 1865). Pencil, ink, and watercolor, 12¼ x 18¾" (31 x 47.7 cm) (irreg.)

92 *The Fallen Angel.* (1871). Charcoal, 11⅜ x 9⅜" (28.8 x 23.7 cm) (irreg.)

93 *Head of a Martyr.* (1877). Charcoal, 14½ x 14⅜" (36.6 x 36.4 cm). Page 50

94 *The Marsh Flower.* (1880–81). Charcoal, 19⅝ x 13½" (49.7 x 34.1 cm) (irreg.). Page 51

95 *Fantastic Monster.* (1880–85). Charcoal, 19⅞ x 13⅝" (50.4 x 34.6 cm)

96 *Orpheus.* (1881). Charcoal, 16¼ x 13¾" (41.8 x 34.8 cm)

97 *A Knight.* (Ca. 1881). Charcoal, 18½ x 13¾" (47.6 x 34.9 cm)

98 *Woman and Serpent.* (1885–90). Charcoal, 20⅝ x 14¾" (52.3 x 37.5 cm). Page 53

99 *Woman in Profile* (facing left). (1890–95). Charcoal, 19¾ x 14¾" (50 x 37.5 cm)

100 *Woman in Profile* (facing right). (1890–95). Charcoal, 17⅝ x 14¾" (44.7 x 37.5 cm). Page 52

101 *Man with a Laurel Wreath.* (Ca. 1895). Charcoal, 20¼ x 14¾"
(51.5 x 37.5 cm)

**ROPS, FÉLICIEN
JOSEPH VICTOR**
Belgian, 1833–1898

102 *Flora.* n.d. Watercolor, gold lacquer, and pencil, 9⅝ x 7⅛" (24.4 x 18 cm).
Page 58

SEGANTINI, GIOVANNI
Italian, 1858–1899

103 *Pastoral.* (Ca. 1890). Crayon, 11⅛ x 17¼" (28.1 x 43.7 cm)

SIGNAC, PAUL
French, 1863–1935

104 Study for *A Time of Concord.* (1895). Chalk, 13⅛ x 13¾"
(33.2 x 34.8 cm). Page 59

**TEIXEIRA DE MATTOS,
JOSEPH**
Dutch, 1892–1971

105 *Self Portrait.* 1918. Crayon and pencil, 18½ x 11⅞" (47 x 30 cm)

THORN PRIKKER, JOHAN
Dutch, 1868–1932

106 *Cherubim.* 1892. Watercolor and pencil, 29⅛ x 20" (73.9 x 50.5 cm)

107 *Haystacks.* (Ca. 1904). Crayon and watercolor, 19 x 23" (48.1 x 58.4 cm).
Page 60

108 *Les Xhorres.* (Ca. 1904). Crayon, 23 x 19" (58.2 x 48.2 cm)

TOOROP, JAN THEODORUS
Dutch, 1858–1928

109 *Fatality.* 1893. Crayon and pencil, heightened with chalk, 23⅝ x 29¾"
(60 x 75.4 cm). Page 56

110 *Self-Reflection.* 1893. Crayon, gouache, brush and ink, and pencil,
6⅞ x 7½" (17.5 x 19 cm)

111 *The Three Brides.* 1893. Crayon and pencil, heightened with gouache,
30⅝ x 39¼" (80.4 x 99.7 cm). Page 57

112 *H. P. Bremmer.* (1894). Pencil, 9⅛ x 6½" (23.2 x 16.5 cm)

113 *Girl from Marken.* September 1901. Pencil, 12½ x 9⅜" (31.6 x 23.6 cm)

**VAN DE VELDE,
HENRY CLEMENS**
Belgian, 1863–1957

114 *Work.* 1889. Chalk, 17¼ x 19" (43.8 x 48.3 cm)

115 *Girl in a Farmyard.* 1891. Chalk, 18¼ x 19⅜" (46.3 x 49.4 cm) (irreg.).
Page 61

116 *Woman Sewing.* 1891. Chalk, 17⅜ x 16½" (44 x 41.9 cm)

117 *Fruit and Vine (Abstract Ornament).* (1892–93). Pastel, 18⅞ x 19⅞"
(47.8 x 50.3 cm). Page 49

VERSTER, FLORIS HENDRIK
Dutch, 1861–1927

118 *Endegeest.* (1893). Pastel, 17 x 26½" (43 x 67.1 cm) (sight). Page 44